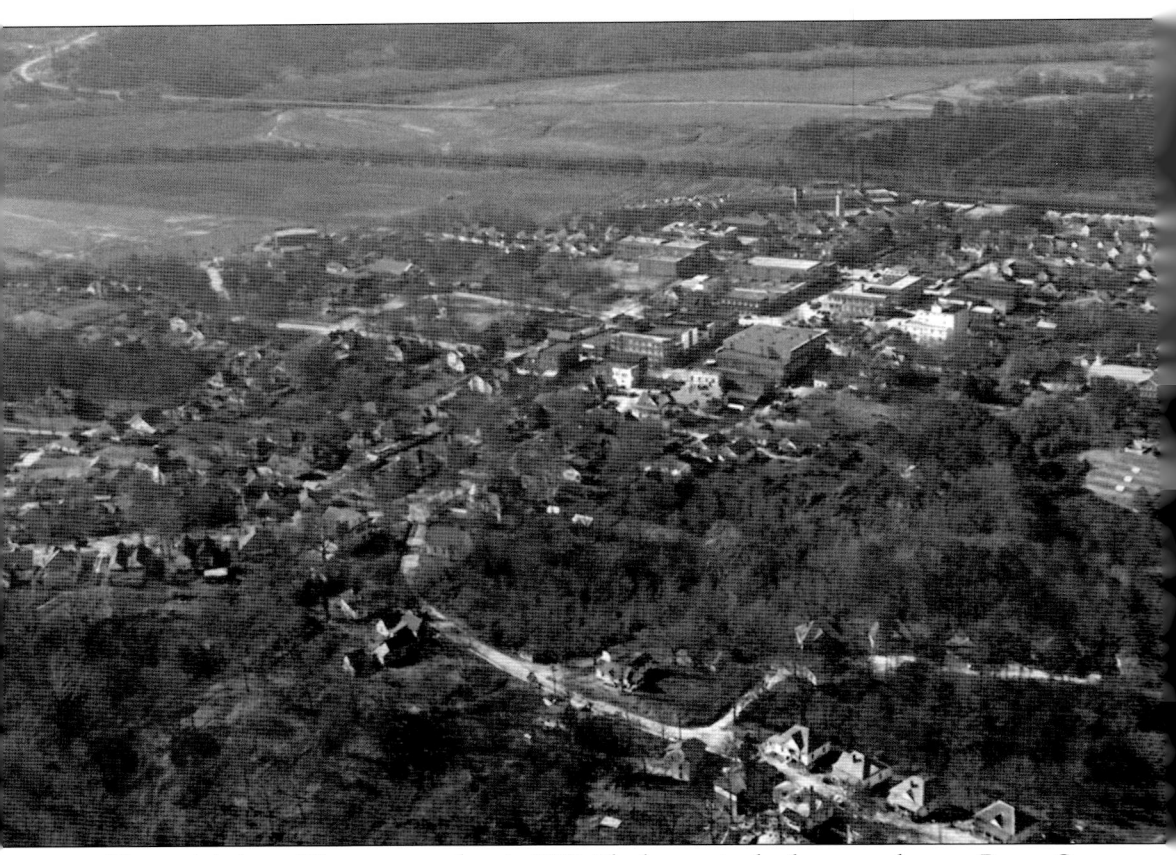

This aerial view of Canton was taken in 1930. The houses in the foreground are on Brown Street. The crescent curve made by the Etowah River is visible to the left and curves back around behind what was Crescent Farm. The fields at the top of the photograph are where the National Guard Armory and Cherokee High School are now located. The center of town and the area named Roosterville are visible to the right. (Courtesy of Cherokee County Historical Society.)

ON THE COVER: Canton's post office opened on August 1, 1929, and remained in use as the post office until 1975. The building was constructed in the Neoclassical Revival style and later served as city hall and the Canton Fire Department. The new post office cost $65,000 and was the first structure in Georgia to be built under the federal Public Buildings Act. The contractor was A.M. Lundberg of St. Louis. The post office was often a gathering place as patrons came to get mail and chat. (Courtesy of Cherokee County Historical Society.)

Rebecca Johnston

Copyright © 2015 by Rebecca Johnston
ISBN 978-1-4671-1388-5

Published by Arcadia Publishing
Charleston, South Carolina

Printed in the United States of America

Library of Congress Control Number: 2014953122

For all general information, please contact Arcadia Publishing:
Telephone 843-853-2070
Fax 843-853-0044
E-mail sales@arcadiapublishing.com
For customer service and orders:
Toll-Free 1-888-313-2665

Visit us on the Internet at www.arcadiapublishing.com

To my grandmother Belle Cochran Wheeler and father, James Walter Wheeler, who instilled in me a love for local history

Contents

Acknowledgments		6
Introduction		7
1.	Early Settlers	11
2.	Civil War	27
3.	Changing Times	41
4.	New Directions	65
5.	Era of Progress	89
6.	Coming of Age	117
Bibliography		127

Acknowledgments

The author thanks all those who lent a hand and took the time to help make this book about Canton's history possible. In particular, the Cherokee County Historical Society (CCHS) and Nell Galt Magruder were instrumental in gathering materials and photographs. To Nell, special thanks are extended for opening her significant family archives for this project and always being supportive of efforts to preserve local history.

Special thanks go to historical society executive director Stefanie Joyner and archivist Lisa Tressler, who dedicated themselves to the task each day and were never too busy to help locate a photograph and find information. Thanks also go to all those who have donated their family photographs to the Cherokee County Historical Society. Most especially, a thank-you is extended to the family of photographer Buddy Alexander for donating his extensive collection to the historical society and to the Jones family for their contributions.

The work that the historical society has done to assemble and archive literally thousands of photographs has laid a foundation for preserving a record of the history of Cherokee County and Canton. Each volunteer and staff member who has had a hand in that is appreciated.

Thanks go to those at the R.T. Jones Memorial Library in Canton who maintain the Georgia Room and its archives on local history and who shared the library's photographs for this project.

A heartfelt thank-you goes to Juanita Hughes, who took the time to edit every word meticulously and, as always, give me encouragement. Juanita shares my love of local history and does much to promote it.

The love of history is something that must be continuously fostered and encouraged. There are many in this community who do that—too many to name—but I thank each of you for all you do.

And a thank-you goes to my husband, Harry Johnston, who puts up with the mess and my moods when these projects are underway and whose memory is better than mine in recalling facts about the community where we grew up.

INTRODUCTION

On December 26, 1831, Cherokee County was formed by the Georgia General Assembly from all the Native Cherokee territory in northern Georgia, and one year later, on December 3, 1832, the original Cherokee County was divided into 10 counties. The new Cherokee County would later be divided again, but the settlement that would become Canton was central to both. The site designated for the new Cherokee County to begin conducting business was the house of an early settler in the area that would eventually become Canton. The first courts for the new county were held there as well.

By the next year, the area was called Cherokee Courthouse, and a post office was established under that name. The settlement was growing up around the Etowah River, and on December 24, 1833, the county seat was formally incorporated by the general assembly under the name Etowah. While there was some talk about moving the county seat to another area, men like William Grisham, John P. Brooke, and Judge Joseph Donaldson are said to have prevailed in keeping it where Canton is located today. The decision seemed the most sensible choice, as the site was in the most densely settled area of the county, and it was already being used for official business. The early settlers were quickly proving themselves to be people of enterprise.

Many of these early settlers came from South Carolina or some older county in northeast Georgia, particularly Hall County. Their foresight in choosing the site for Canton, which officially obtained that name on December 18, 1834, was based in wisdom and experience. Canton was situated where the Etowah River curves in a one-mile semicircle, almost centrally located in today's Cherokee County. The land around Canton presented prime possibilities for agriculture and farming. Gold had already been discovered in Cherokee County, and the area was rich in other mineral resources. Timber and water were plentiful, making it a superb location for the early pioneers to put down roots.

During Canton's first 50 years, while it was for the most part a small village, it was the center of social, educational, and commercial endeavors for the entire county and beyond. Because of the caliber of those early settlers, the town grew in a cultured fashion. In 1833, a church and a school were established. The school was chartered by the state government as Etowah Institute and served the needs of the community for the next 70 years. The Baptist church was started with 10 members, and both the church and school were founded under the leadership of William Grisham. He came to Georgia in the 1820s and to Canton several years before the city was incorporated.

In 1838, the federal government rounded up all Cherokees still living in Canton, and the county and began a removal process that was a dark period in the history of the area. In all, a total of more than 1,300 local Cherokees were taken into custody by soldiers, and most were held at Fort Buffington until they were marched west on what became known as the Trail of Tears.

In the years between 1834 and 1850, white settlers poured into Cherokee County and Canton. Census figures show 1,342 "free, white inhabitants" lived in Cherokee County. By 1850, there were more than 12,000. The settlement included gristmills, sawmills, and mining projects. The

town had a livery stable, several general stores, and other enterprises. There was a courthouse, a jail, and a number of lawyers.

Another settler of note was Dr. John Washington Lewis, who moved to Canton in 1838 and built the house on what would eventually become known as the Brown Farm. He is said to have been a descendant of George Washington and was a lawyer, physician, Baptist preacher, and farmer. Dr. Lewis was instrumental in bringing Canton's most notable resident, Joseph Emerson Brown, and his brother, James Rice Brown, to the area. Lewis paid for both men to attend Yale University and supported them in their efforts to be admitted to the bar. Joseph Brown was elected governor in 1857 and served throughout the Civil War years.

These men were instrumental in those early years before the war, establishing Canton as a center of industry and commerce with plans for ironworks along the Etowah River and bringing the railroad to Canton. The Civil War halted many of those plans, at least temporarily.

With Canton firmly established as a commercial and agricultural center and home to men of great leadership capabilities, the war brought both challenges and trials for those living there. Most of the leaders supported the cause, and as soon as the decision to secede was made and Governor Brown called for an army, legions of men from Canton stepped up to volunteer, although there were still some Union sympathizers in the area. But the majority were willing to fight, and with a great deal of fanfare, Confederate soldiers marched off. The ensuing years turned out to be fraught with unimagined hardships, including the burning of most of the town by General Sherman's troops in 1864. The men who returned and their families who remained faced a different Canton when the war ended.

But it would not be long before the town found its footing again and, with a resilience that was a hallmark of those who settled the area, began to build once more. By 1870, Canton had reached a population of 200 people. For a number of years following the war, Joel Galt was a leading businessman and merchant. Shortly after the war, Capt. Joseph Miller McAfee, who fought under Stonewall Jackson, came to Canton and established himself as a leading merchant. By 1874, he owned a mercantile business, hotel, brickyard, and other enterprises. In 1870, Benjamin Franklin Crisler came to the town and established a general merchandise store, tannery, and shoe and harness business.

Then, in 1879, two events happened that would further propel the town along. At that time, the population was around 360 people. In the fall of 1879, the Marietta & North Georgia Railroad ran its lines from the south to Canton, opening up the city to the outside world and providing a way to trade easily with other regions. That same year, lured by the opening of the railroad, Robert Tyre Jones moved to Canton. He was a young man who would help shape the town in new ways, first through local business and later by opening a cotton mill in the town. In 1879, Canton also got a new weekly newspaper, the *Cherokee Advance*, under the direction of Benjamin Franklin Perry. With the establishment of Jones Mercantile Company, R.T. Jones began a commercial dynasty that would touch almost every aspect of the city's growth and development. The railroad also allowed the city to become one of the leading cotton markets in Georgia, with the annual shipment reaching 3,000 bales in 1883.

In 1882, the city established a mayor and council to govern, and Odian W. Putnam was chosen as the first mayor of Canton. The city had originally been governed by five commissioners. That same year, the town got its first bank, the Bank of Canton, the only financial institution in Cherokee County. With the arrival of the railroad, Canton also quickly established as a healthful resort town with several boardinghouses and hotels and an alum spring that was considered to have medicinal properties.

What Canton still lacked was manufacturing, but in 1891 the Georgia Marble Finishing Works was founded by Thomas M. Brady, and was the first of several plants to finish the marble being quarried in north Cherokee and Pickens County. Georgia Marble quickly established itself nationally, and other marble plants in Canton followed, providing some jobs for residents.

In 1899, the opening of Canton Cotton Mill by R.T. Jones and a number of leading citizens provided the jobs and opportunity the town needed to see substantial growth and wealth beyond

mining and farming industries. The cotton mill was erected on the banks of the Etowah River, and it was successful from its inception. A second mill was built in 1923, increasing production and offering more employment opportunities. With plentiful jobs, the town quickly grew and reached a population of 2,893 by 1930.

Although the Great Depression took its toll, Canton weathered the hard economic times better than most areas, thanks in part to the resilience and thriftiness of its residents and the mill and agricultural resources. Out of those days, a new industry was born that brought a renewed economy, the poultry business. Started out of hard times, by the 1940s and into the 1950s, poultry and its subsidiary businesses brought a boon to the local economy that was sorely needed and much welcomed.

In 1955, Canton was struck by one of its worst disasters when it almost burned for the second time. A manufacturing plant downtown, Cantex, caught fire from a boiler explosion on June 29, 1955. The fire quickly spread, damaging or destroying nearby buildings, including the *North Georgia Tribune* office and the Chevrolet dealership. Firefighters from neighboring areas poured in, and the fire was eventually extinguished, but not before leaving a lasting mark on the city.

In the 1960s, a number of older homes and structures in downtown Canton were torn down to make way for the modern era many were ready to embrace. Among them were the Hotel Canton, the McAfee house that served as the library at the time, and several old and venerable residences. New buildings replaced the historic buildings that told of the past, changing the face of Canton.

In 1981, Canton Textile Mills, as it was then known, closed its doors forever, leaving many families wondering how they would make ends meet. Fortunately, that same year, the Interstate 575 project was completed to Canton, opening the town to the metro area and making it possible for residents to commute.

In the 1990s and early 2000s, Canton grew exponentially as the economy boomed, then in 2008, the Great Recession once again brought unexpected change and a sluggish economy. Still, the county seat remained, just as it always had been, the center of education, commerce, government, and social endeavors for Cherokee County. In those years, a new Cherokee County Justice Center was built downtown, older buildings were revitalized, a new hospital was planned, and parks were built and improved. By 2014, the city's population was more than 24,000 people, and the future continued to look bright as it had to those first settlers in the early 1830s.

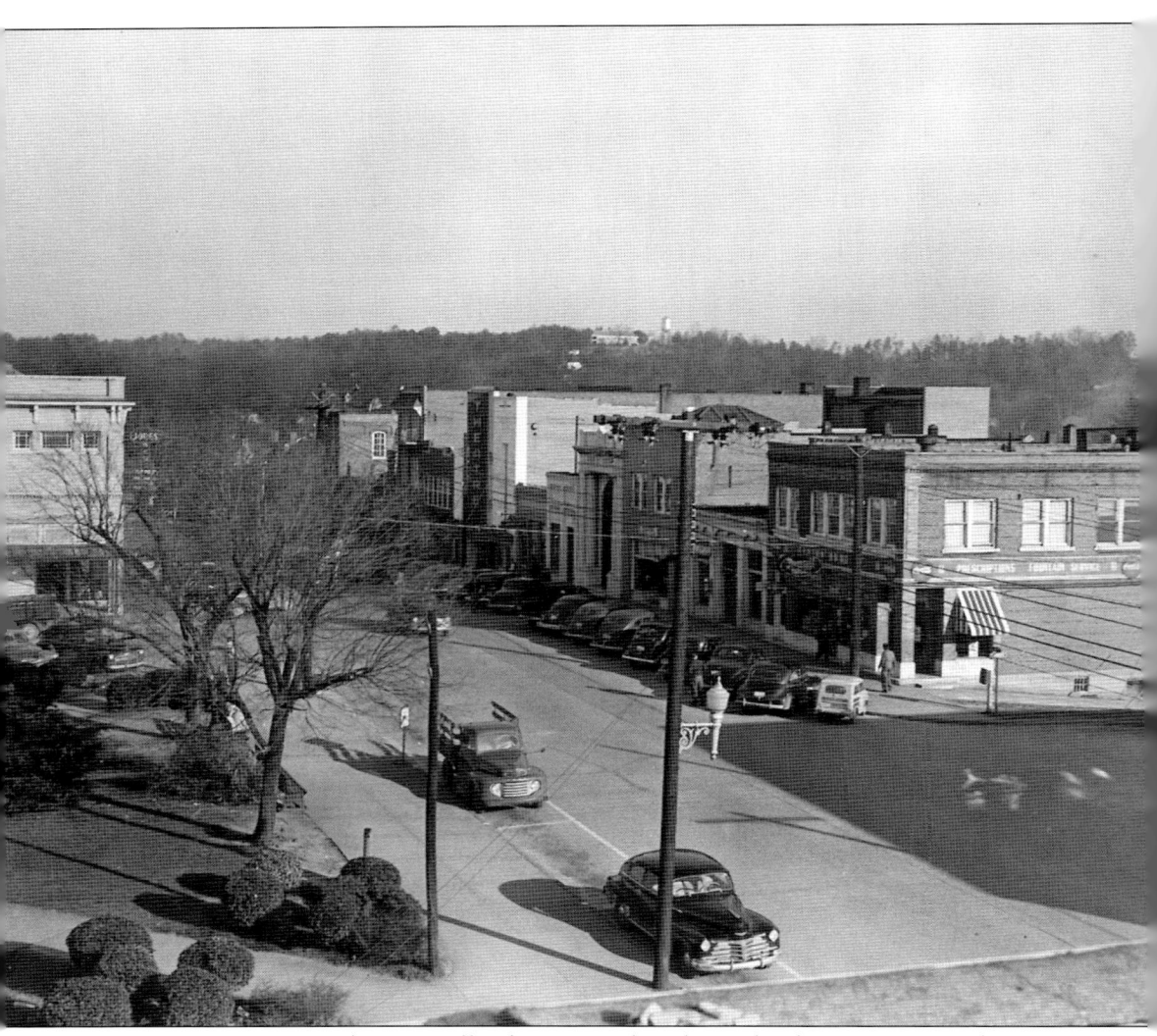
Canton's Main Street in the 1940s offered visitors and residents a lovely town square and numerous active commercial establishments, including Jones Mercantile Company, Bank of Canton, the Canton Drug Company, and many more. The downtown area was a place to congregate for social events, church life, education, and business, and it was the center of the largest city in the county and the county seat. (CCHS.)

One
EARLY SETTLERS

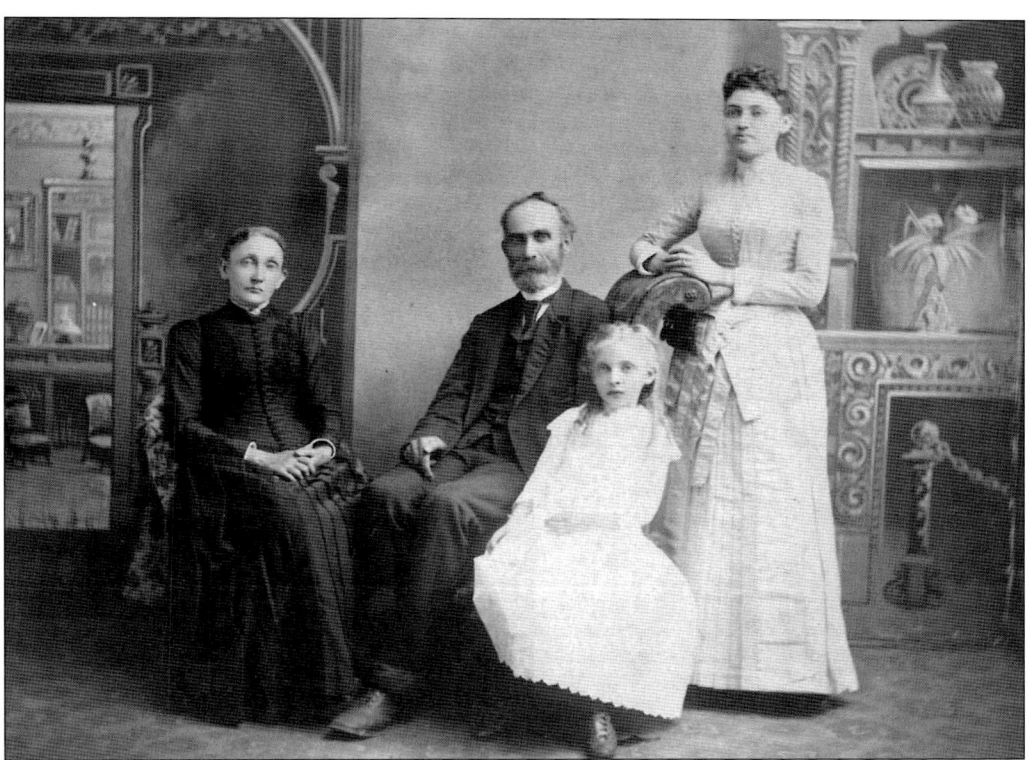

Odian Wilson Putnam (1832–1913) was the first mayor of Canton. He is pictured here with his wife, Martha Tate Putnam (left), and daughters Lutie Putnam and Lecy Putnam (standing). Putnam was a lieutenant in the Confederate army and fought in the Battle of Gettysburg, where he lost his left arm. The city did not have a city council until 1882. Putnam was elected one of five councilmen by the voters on January 7, 1882, and chosen by the council as mayor on January 21, 1882. (Courtesy of Nell Galt Magruder.)

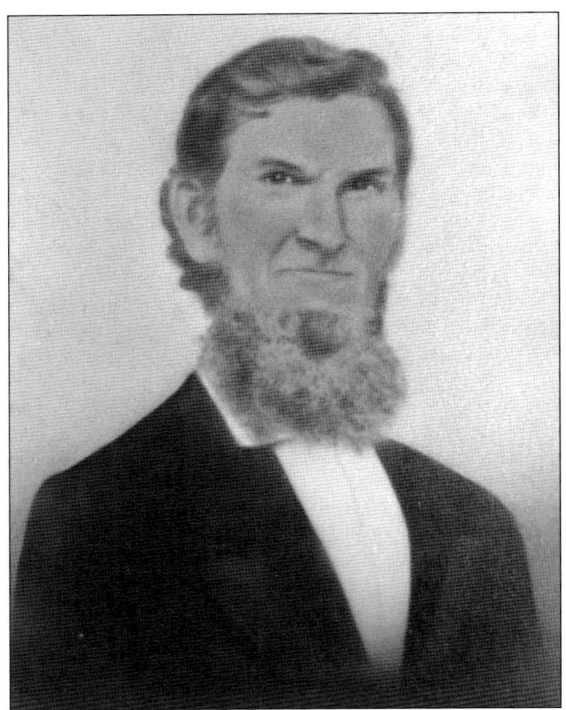

William Grisham (1803–1876) was an early pioneer settler of Canton and one of three men credited with founding the town. Grisham, who was born in South Carolina, moved to Canton about 1832 with his wife, Susan Bradford Grisham. When Canton was incorporated on December 24, 1833, under the name Etowah, Grisham was instrumental in seeing it was chosen as the county seat of Cherokee County. The name was changed to Canton on December 18, 1834, and Grisham, the town's first postmaster, sent the name to the postal service. (CCHS.)

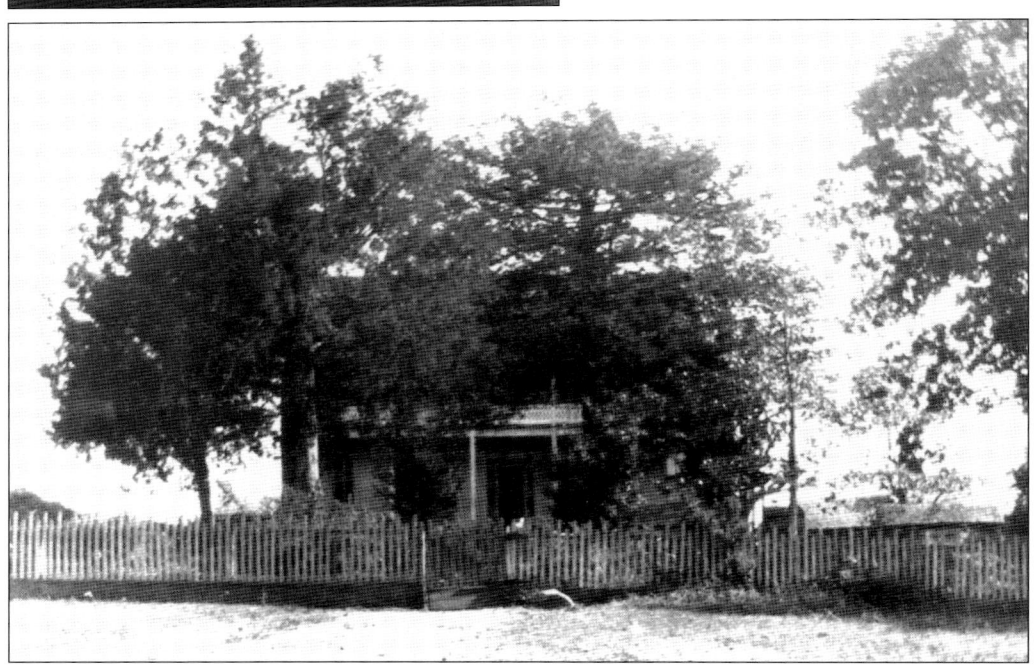

In 1841, William Grisham built his home in Canton, and it is perhaps the oldest standing home downtown. Grisham had already been living in Canton for nine years, and descendants believe he might have been living in a one-room home on the site. The two-story home was built in the Georgia plain style, and there were outbuildings such as a smokehouse and summer kitchen. (Courtesy of Nell Galt Magruder.)

The Grisham home was spared in 1864 when Sherman's troops burned much of Canton, possibly because one of the residents displayed a Masonic symbol to the Union soldiers. The house has undergone several renovations over the years and was given Victorian details in 1903. In 1957, Grisham's descendants replaced the Victorian front porch with a neoclassical portico, graced with Ionic columns. A descendant of Grisham, Nell Galt Magruder, and her husband, Bill Magruder, reside in the home. (CCHS.)

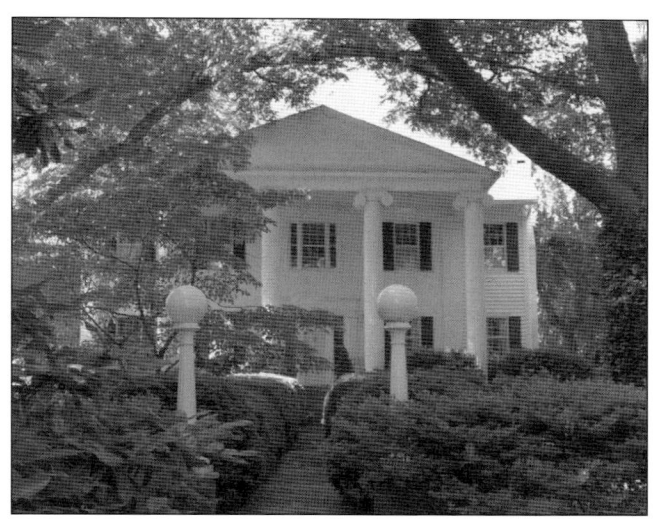

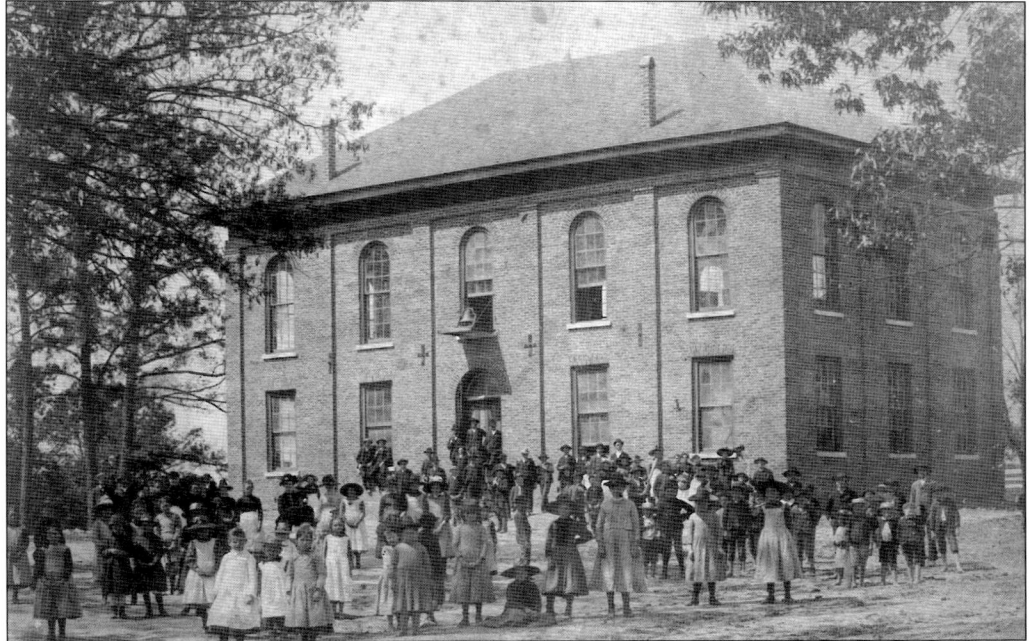

Etowah Institute in Canton was the town's first state-recognized school, chartered in 1833 by the state legislature. The first classes were taught by Joseph Knox, the earliest known school teacher in the county. Knox married Malissa Brooke, daughter of John P. Brooke, one of the three founders and earliest settlers of Canton. The school was an advanced institute of learning, with children of well-to-do settlers as pupils. The impressive two-story building was on the site where the Canton School was later located on Academy Street. In 1844, when future governor Joseph Emerson Brown first moved to Canton, he taught at the institute. This early photograph of the school is undated. (CCHS.)

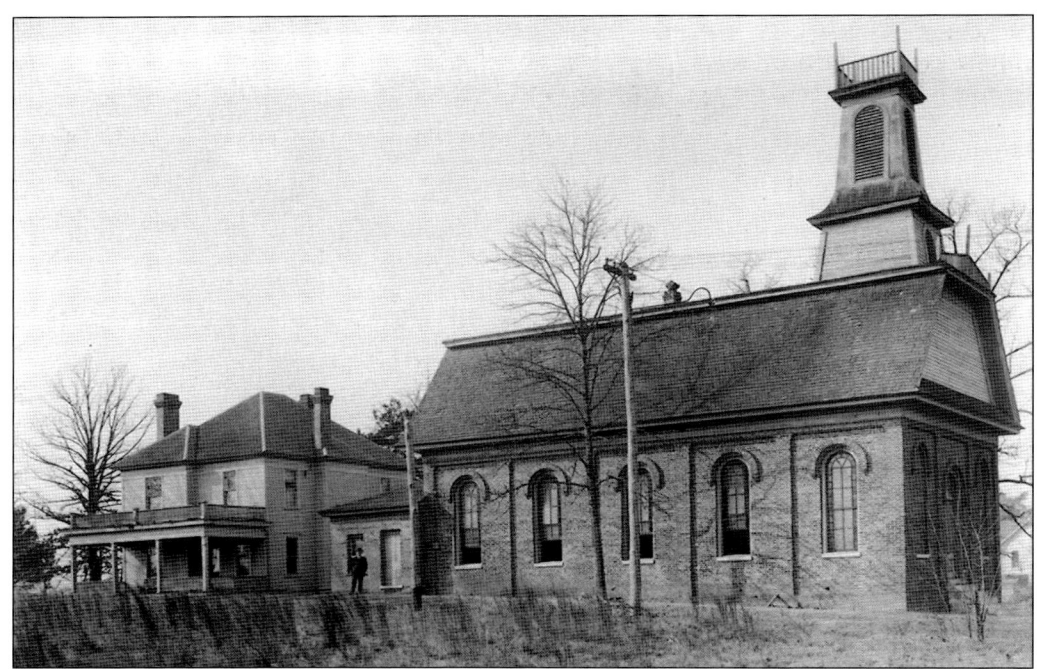

The Canton Baptist Church was the first church established in Canton and was constituted in August 1833. Canton was then called Cherokee Courthouse and the church was named Ararat at Cherokee Courthouse by the Reverend Jeremiah Reeves and William Manning, missionaries for the State Baptist Convention. Members were William and Susan Grisham, Moses and Elizabeth Perkins, Elias and Faith Putnam, James and Mary Wilson, and Daniel Butler and Julia Burns. The second church building was erected in 1883 on land deeded by former governor Joseph E. Brown in 1882. The parsonage sat behind the church, facing the courthouse on the square. (CCHS.)

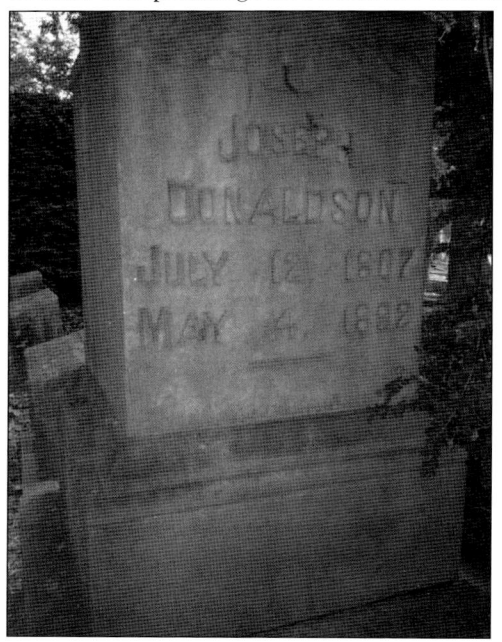

Judge Joseph Donaldson (1807–1882) was one of the town's founders, and he donated the land for Riverview Cemetery behind the Methodist church in 1844. Donaldson had a large plantation, and his home was where the hospital was later located in North Canton. In the 1850 census, he is listed as having 26 slaves, a large number for Canton. His home was known as a center of hospitality. Lloyd G. Marlin says in *The History of Cherokee County* that Donaldson brought 100,000 silkworms to Canton and planted mulberry trees in a plan to establish a silk industry. (Author's collection.)

Malinda Ann Field Donaldson (1811–1883) was the daughter of Jeremiah Field, and she married Judge Joseph Donaldson in 1833. She and her husband had five children. According to some accounts, one of their sons died building a bridge over the Etowah River in 1870. (Author's collection.)

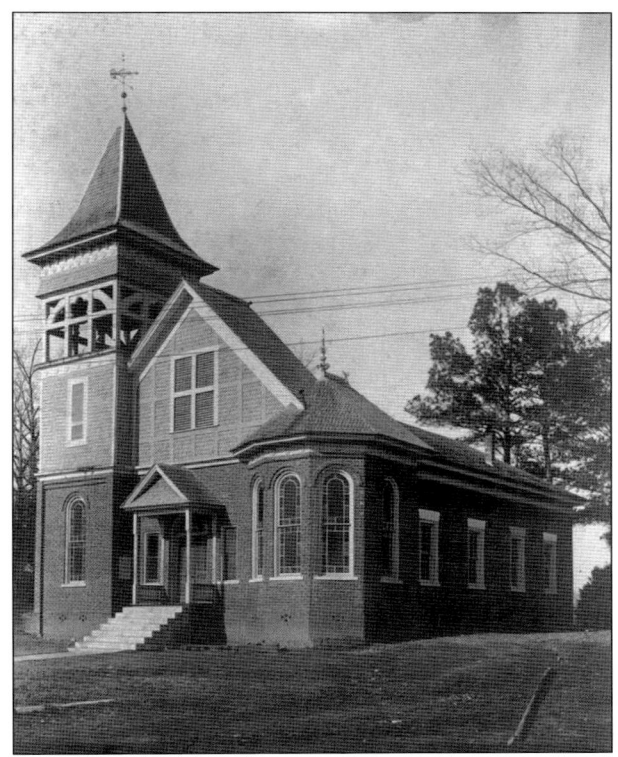

Judge Joseph Donaldson helped in establishing the Canton Methodist Church. Donaldson was one of the three pioneers credited with establishing Canton as a town and as the county seat. He served several terms as justice of the inferior court of Cherokee County, including from 1834 to 1837. This building was constructed in 1850 and later replaced in 1925 with the brick building that today houses the Cherokee Arts Center. (CCHS.)

Riverview Cemetery was located behind the Canton Methodist Church. The land for both was donated in 1844 by Judge Joseph Donaldson, one of the earliest settlers of Canton. The first documented burial was that of an infant, Susan Moss, daughter of Felix and Eady Moss, in May 1844. The cemetery has about 800 to 900 gravesites, many of them notable early settlers. Pictured here is a graveside service, perhaps in the early 1900s. (CCHS.)

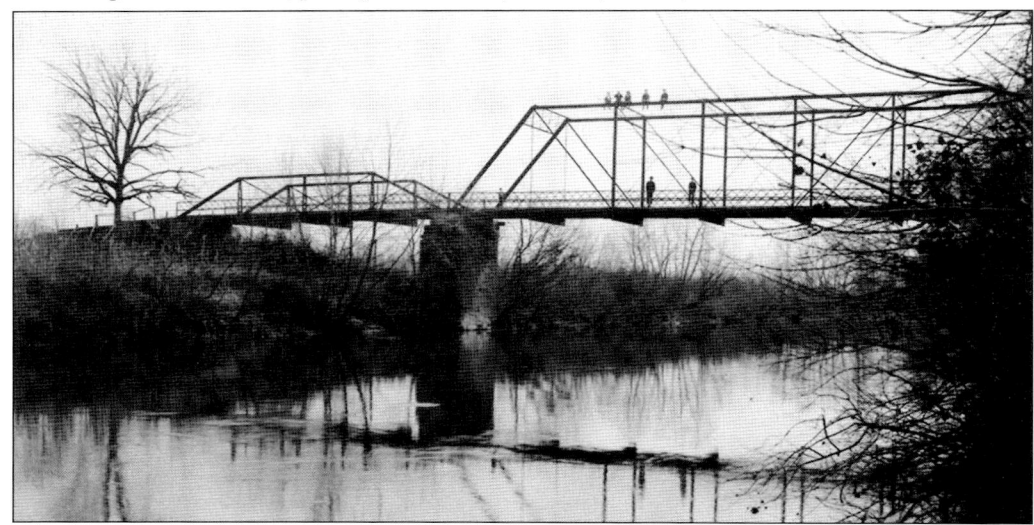

The Etowah River curves in a mile-wide semicircle in the center of Cherokee County, where Canton was originally settled. The bridge across the river gives access to North Canton and Waleska. In earlier times, a ferry was used, which is believed to have been established by Judge Joseph Donaldson. Donaldson is also believed to have built the first bridge on the road leading from Canton to North Canton, which was a toll bridge by some accounts. The wooden bridge was burned by Union troops during the Civil War. Here, workers construct a bridge in the early 1900s that helped connect the town to the northern portions of Cherokee County, making travel and commerce easier. (CCHS.)

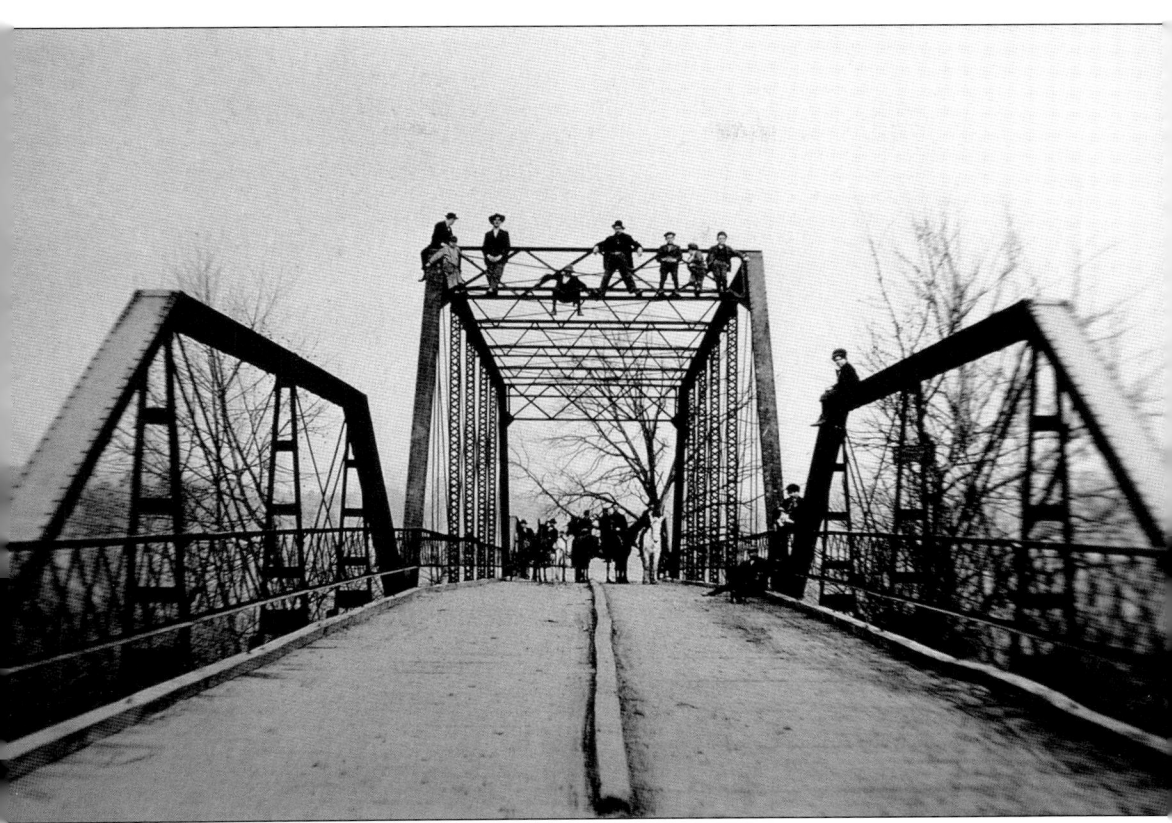

A bridge was constructed across the Etowah River to connect the town to North Canton after the Civil War. The wooden bridge was burned by Sherman's troops, who also burned many of the homes and businesses. An iron bridge is mentioned in the *Cherokee Advance* as early as 1883. Much of Canton's early growth and success was built on its proximity to the river and rich agricultural land along the waterway, as well as the resourcefulness and hard work of the early settlers. (CCHS.)

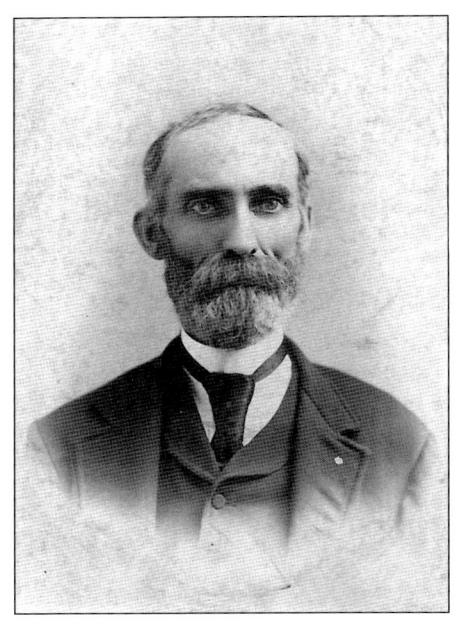

Odian Wilson Putnam was the son of early Cherokee County settler David Putnam, who came to the Little River area around the time the county was chartered. Odian was clerk of the superior court of Cherokee County from 1856 to 1875 and county ordinary from 1885 to 1893. He was a prisoner of war on Johnson's Island in Ohio for almost two years. Odian returned to Cherokee County after the war, married Martha Tate in 1868, and moved to Canton in 1877. He was also the first mayor. (Courtesy of Nell Galt Magruder.)

Odian Wilson Putnam built this home in 1888, and it is still occupied by descendants of the family. Pictured here are, from left to right, family members from three generations of the family: Lutie Putnam Johnston and Green Johnston, Odian and Martha Putnam, Odie Putnam Galt, Mr. and Mrs. William Galt. The children are Martha Galt, Frances Galt, Marjorie Johnston, and Elizabeth Johnston, Odian and Martha's grandchildren. (Courtesy of Nell Galt Magruder.)

Joel Galt (1817–1873) was born in South Carolina and came with his parents, Jabez Galt and Frances Machen Galt, to Cherokee County in the 1830s. Jabez was one of the first merchants in Canton, and he constructed a brick building in Canton in 1839. Joel carried on the family mercantile business, and he was a member of the home guard during the Civil War and a clerk of the Baptist church for many years. He was married to Malinda Grisham, the daughter of William Grisham, town founder. (Courtesy of Nell Galt Magruder.)

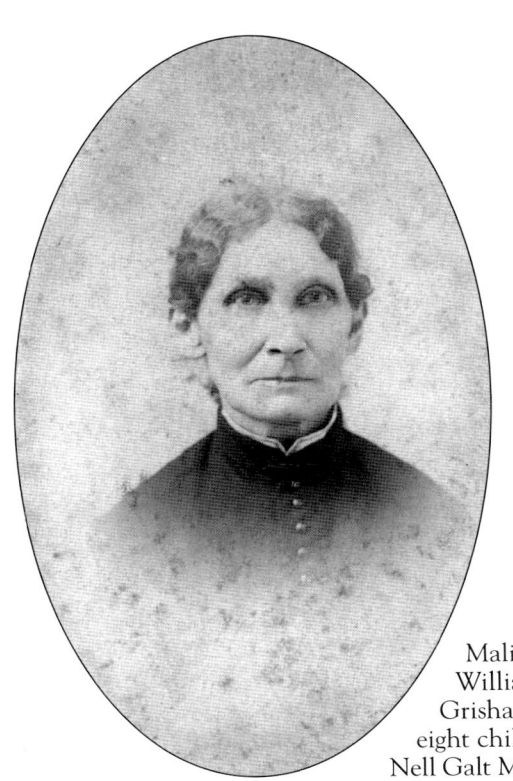

Malinda Caroline Grisham Galt was the daughter of William Grisham, town founder, and Susan Bradford Grisham. In 1844, she married Joel Galt, and they had eight children, one of whom died in infancy. (Courtesy of Nell Galt Magruder.)

19

The home of Jabez Galt was located on Marietta Street behind what is today the Canton City Hall, the former Canton First Baptist Church. Galt was a leading merchant and prominent citizen of Canton. He was married first to Ella Speir, and they had one son. After her death, he married Lizzie Teasley, and they had nine children. The home was converted to Coker Hospital in 1923 and torn down in the 1960s. (CCHS.)

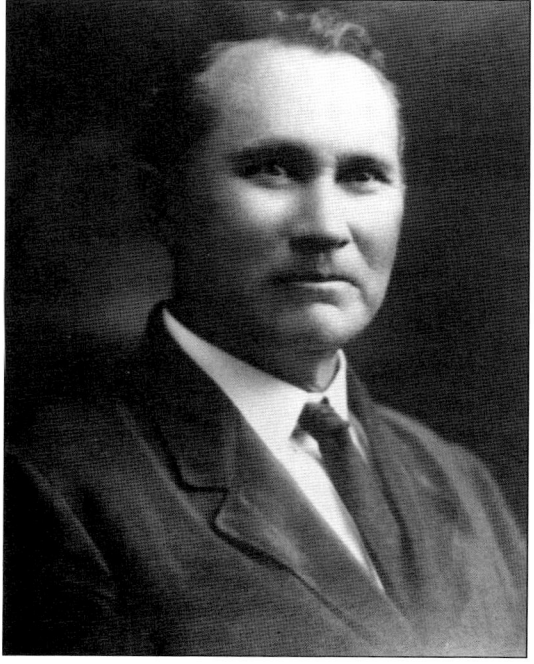

Jabez Galt (1851–1916) was the son of Joel Galt and Malinda Grisham Galt and named for his grandfather. He was a leading merchant in Canton and superintendent of schools from 1908 to 1911. He owned mining and agricultural interests and was an active member of the First Baptist Church of Canton, where he organized its first Sunday school. (Courtesy of Nell Galt Magruder.)

Lecy Putnam Galt was the daughter of Odian Putnam and Martha Tate Putnam. She attended school in Canton and went to Mary Sharp College in Tennessee, where she studied music. She married William Galt in 1889, consolidating two of the city's prominent first families. They had three children—Odian Putnam Galt, Martha Galt, and Frances Galt. (Courtesy of Nell Galt Magruder.)

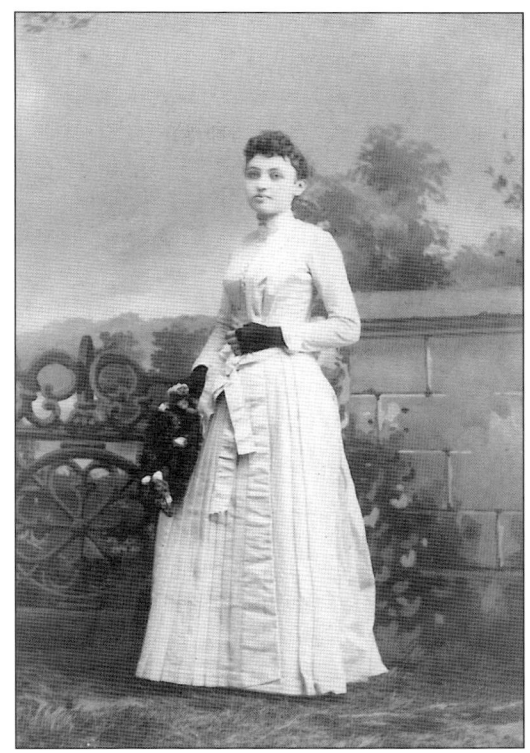

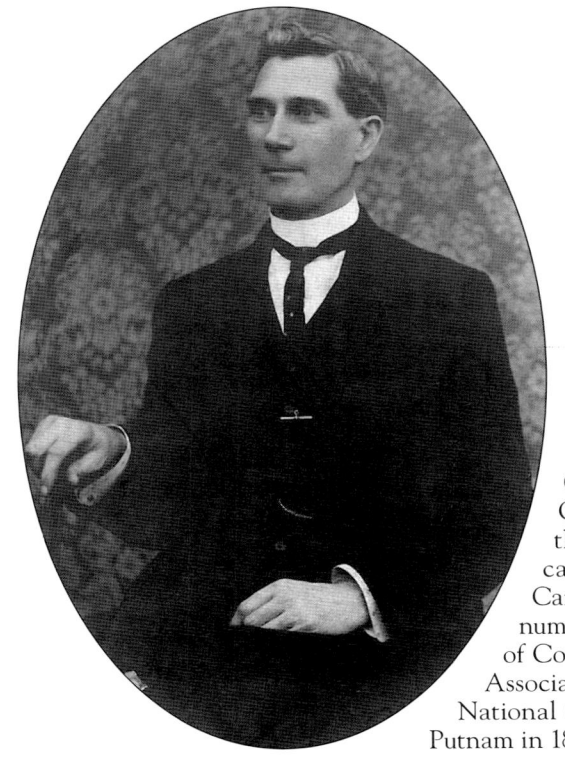

William Galt (1861–1931) was the son of Joel Galt and Malinda Grisham Galt and attended Canton public schools, then graduated from the University of Georgia. He had a stellar career with the Bank of Canton, served as Canton mayor and councilman, was involved in numerous activities, such as the Canton Chamber of Commerce, and chaired the Georgia Bankers Association. He was a delegate to the Democratic National Convention in 1924, and he married Lecy Putnam in 1889. (Courtesy of Nell Galt Magruder.)

Marjorie and Elizabeth Johnston were the daughters of Lutie Putnam Johnston and Green Johnston, among the early families of Canton. Their grandfather Odian Putnam was the first mayor of Canton. They taught grammar school classes at Canton Elementary School and were beloved teachers of many. (Courtesy of Nell Galt Magruder.)

Martha Galt, a descendant of William Grisham, lived in the home the early settler built for most of her life. She was an accomplished pianist and played the organ at the First Baptist Church of Canton for years. Her family was one of the founders of the church and remained active for more than 100 years. Here, she is preparing to give her graduation recital at Shorter College in 1915. (Courtesy of Nell Galt Magruder.)

John Prescott Brooke (1795–1880) was one of three founders of Canton, and he is credited with giving half the land for the town. He was sheriff of Cherokee County, commissioned in March 1833. Brooke was born on the ship his parents sailed on from Ireland during their voyage to America. He lived in Pickens County, South Carolina, and Hall County, Georgia, before moving to Canton in 1830. Brooke possibly owned a tavern located about where the county school board office is on Main Street. He was a member of the Georgia Legislature in 1844. (CCHS.)

In 1812, Hester Bennett married John Prescott Brooke, one of the founders of Canton, in South Carolina. She and her husband had 13 children. Ten of their children were born in Hall County, Georgia, before they moved to Canton, and the youngest three were born in Cherokee County. (CCHS.)

23

George Washington Brooke (1829–1912) was the son of Canton founder John P. Brooke. He was educated in local schools and served in the Confederate army as a second lieutenant. Brooke fought in the Battles of Chickamauga and Lookout Mountain, was captured near Dalton, and was held as a prisoner in Ohio. Raised in Canton, he later had a plantation near Woodstock but returned to Canton in 1885 and bought the Reverend B. Cowart's home on Main Street, which burned in 1940. Brooke and his wife are buried in Canton's Riverview Cemetery. (CCHS.)

In 1856, Mary Elizabeth Dial (1837–1935) married George Washington Brooke in Canton. She was a well-educated woman and had a reputation as a wonderful cook and hostess. During the Civil War, she took in paying guests to keep her family together while her husband was away serving. The Brookes had seven children. (CCHS.)

Howell Brooke (1887–1960) was the eldest of eight children born to Jefferson Prescott Brooke and Maud Edgar Brooke. Pictured here around 1912, he began his law practice in Canton, served as a state representative in the Georgia legislature early in his career, and went on to be the judge of the Blue Ridge Judicial Circuit in Canton from 1948 to 1960, when he died of a heart attack. (CCHS.)

Annie Laurie Brooke, wife of Howell Brooke, is pictured here with their children—from left to right, Ann, James, and William. James died at age 4 of typhoid fever. The photograph appeared in the *Atlanta Constitution* for a Mother's Day article with leading members of the Georgia Woman's Christian Temperance Union. The Brooke family were among the earliest settlers of Canton. (CCHS.)

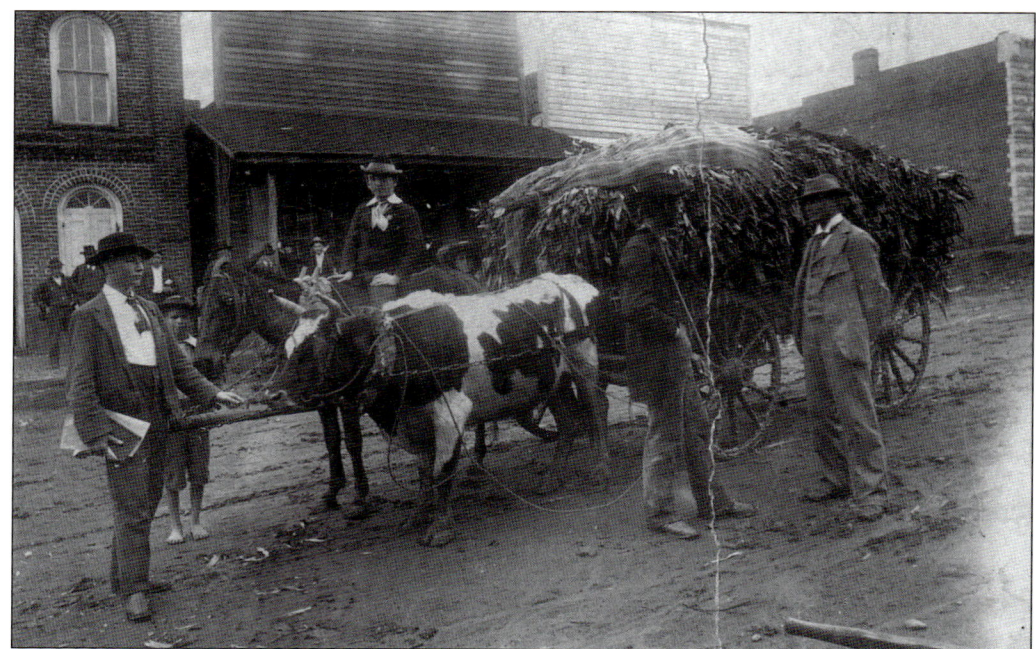

A fodder-filled wagon on Canton's Main Street in this early photograph shows the type of simple buildings that lined the muddy dirt thoroughfare in the town's center. Canton was not large enough to be included in the census until 1870, although it was originally established in 1833 as the county seat. While it was still a small rural town with only about 250 people until the 1880s, it was the chief commercial, educational, and social center, according to Lloyd G. Marlin in his 1932 book, *The History of Cherokee County*. (CCHS.)

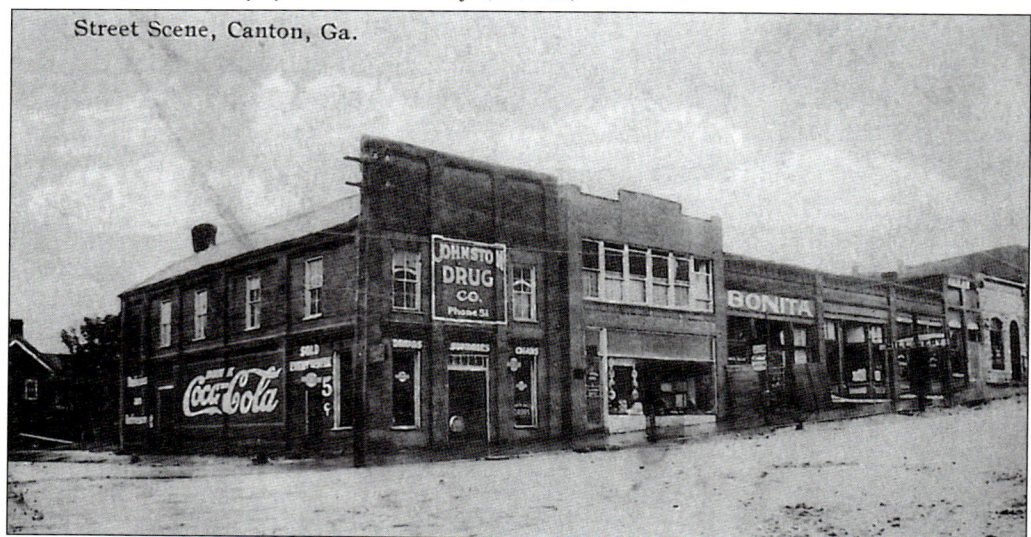

Johnston Drug Store sat at the corner of Main Street and today's Marietta Street and was owned by Green Johnston. In 1884, Canton had two drugstores, 13 stores, two blacksmith and wagon shops, a steam-planing mill, a furniture shop, a photograph gallery, a jewelry shop, and a millinery shop, among others. The town was booming with business following the coming of the railroad in 1879, which spurred growth and brought new people to the area. (Courtesy of Nell Galt Magruder.)

Two

Civil War

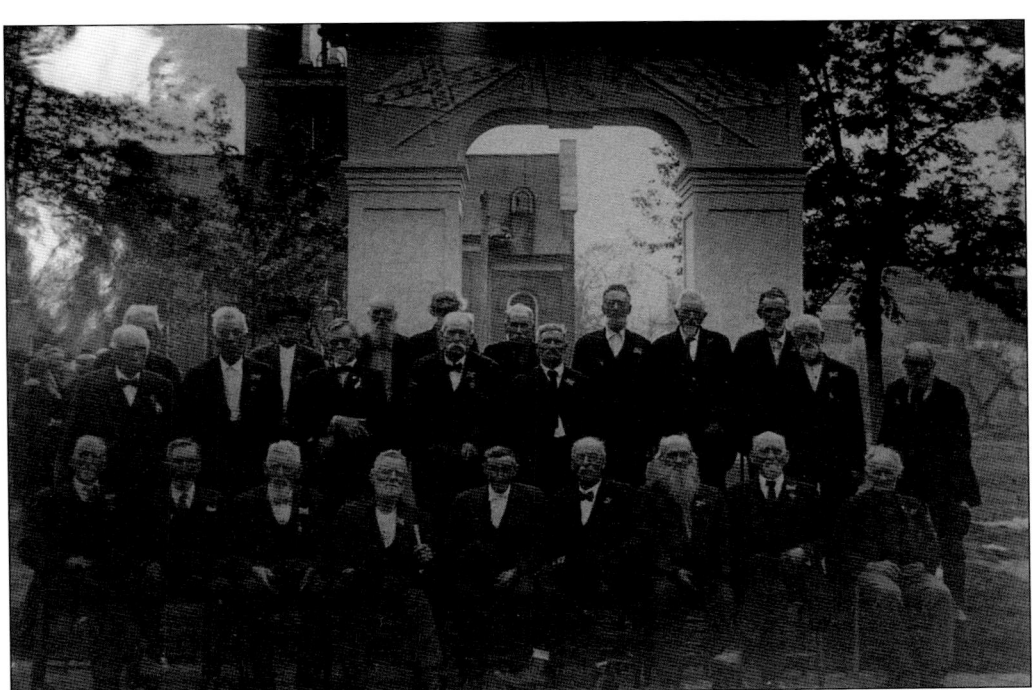

In 1923, a white marble arch was placed in Brown Park in memory of Gov. Joseph Emerson Brown, wartime governor of Georgia, whose home on the site was burned in 1864 by Sherman's troops. The monument reads, "Erected by the Helen Plane Chapter Daughters of the Confederacy. In memory of our Southern Heroes of the War Between the States." Confederate veterans in attendance at the ceremony are pictured. (Courtesy of R.T. Jones Library.)

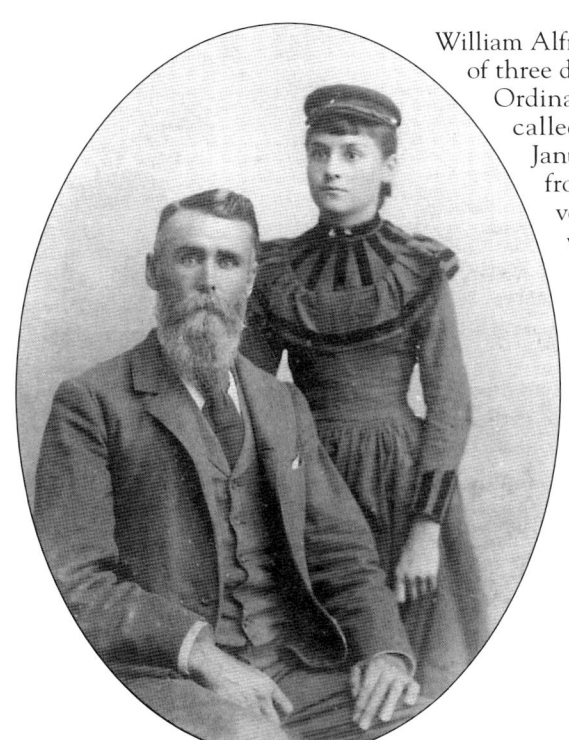

William Alfred Teasley (1833–1908) of Canton was one of three delegates from Cherokee County to sign the Ordinance of Secession at the state convention called by the Georgia General Assembly on January 16, 1861, to decide whether to secede from the Union. Teasley was a unionist and voted against the original amendment, but he voted in favor of the second one to come to a vote at the assembly, once it was assured passage, out of patriotism for his state. His vote against the original secession ordinance reflected the sentiments of many in the county who did not fully embrace the idea of leaving the union. After the war, he served as a judge, state representative, and banker. He is pictured here with his wife, Lucinda Jane Baber Teasley (1837–1892). (Author's collection.)

Elias Earle Field (1820) was one of three signers of the Ordinance of Secession to withdraw the state of Georgia from the Union. Field was a respected planter and the son of one of the earliest settlers of Cherokee County. The Field family, of French descent, owned 3,000 acres southwest of Canton on the Etowah River. Field worked as a merchant in Canton for several years before returning to the family farm. He served as commissary officer with the rank of colonel during the Civil War and raised a company named Field's Guards, which went to the front to fight, although Field was too old and in poor health to personally serve at the front. (Courtesy of Randy Saxon.)

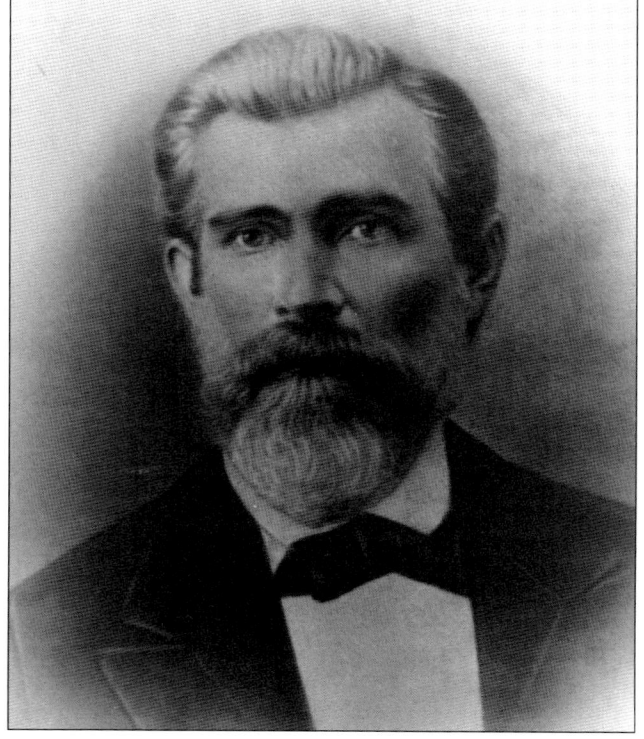

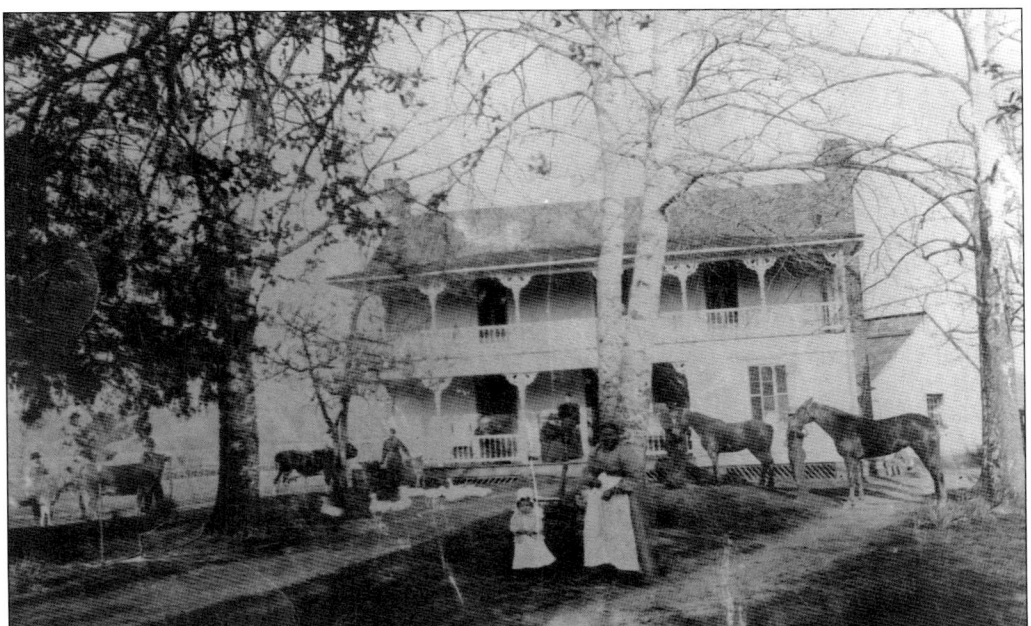

The Field Plantation was one of the largest farms in Cherokee County. In this photograph, possibly from the late 1880s, Miss Lucy, a slave who stayed on with the family after the Civil War, is pictured with one of the Field children. The home was built by Jeremiah Field and known for producing exceptional cotton, corn, cattle, and livestock. The house and land was known as Etowah Vale, and the farm operated under that name until 1949, when it was condemned to make way for Lake Allatoona. (Courtesy of Randy Saxon.)

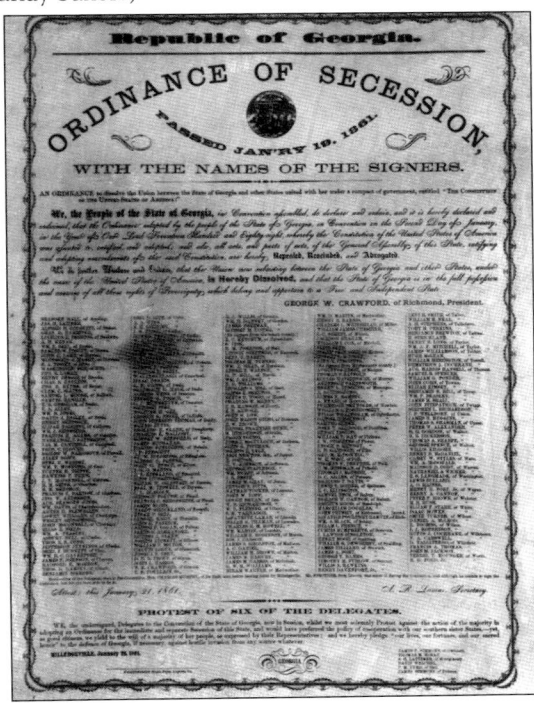

The Georgia Order of Secession was signed by three men from Cherokee County—Elias Earle Field, John McConnell, and William A. Teasley. In January 1861, they traveled to Milledgeville, the state capital, for the Georgia Secession Convention to decide whether the state would withdraw from the United States. Delegates were chosen by voters in an election held January 2, 1861, to decide who would represent each county at the convention. (Courtesy of Randy Saxon.)

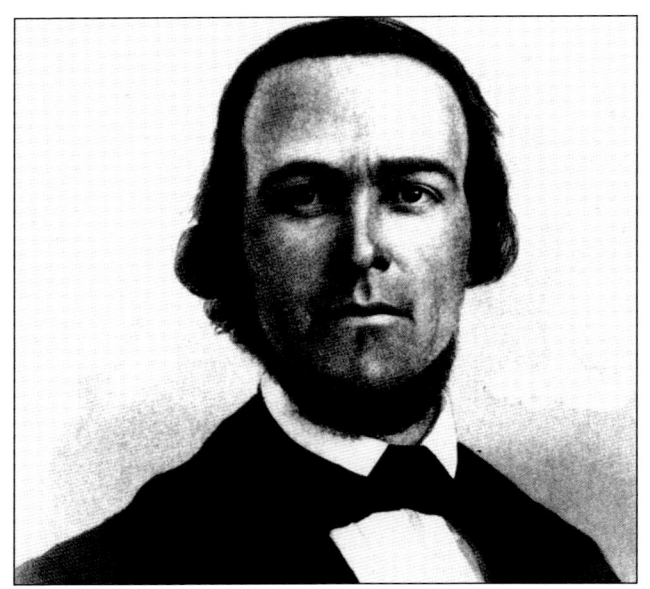

Joseph Emerson Brown came to Canton as a young man, first teaching school and later practicing law after a year studying at Yale University. His abilities as a lawyer quickly propelled him into a prosperous legal practice, and his natural ability as a politician earned him the respect of all those he met. He also began to acquire real estate holdings and amassed the beginnings of what would grow to a sizable fortune in land and investments. He first served as state senator before being elected Georgia's governor in 1857 for the first of four two-year terms. (CCHS.)

This Civil War certificate was presented to Nevel Riley Lawson in 1862 by Gov. Joseph Emerson Brown, who lived in Canton at the time he was elected. The certificate was presented at the time Lawson enlisted as a private in Company A, Cherokee Revengers, of the Cherokee Legion. (Courtesy of Karen Smithwick and Jennifer Bagwell.)

Joseph Emerson Brown (1821–1894) is Canton's most illustrious resident, serving as governor of Georgia for four terms from 1857 to 1865 and leading the state during the turbulent days of the Civil War. When he was elected, he was known as "Young Hickory" and supported by white masses. After the war, he was arrested and briefly imprisoned in Washington, DC, but later pardoned. He served as chief justice of the Supreme Court of Georgia from 1868 to 1870 and went on to be a US senator from 1880 to 1891. (CCHS.)

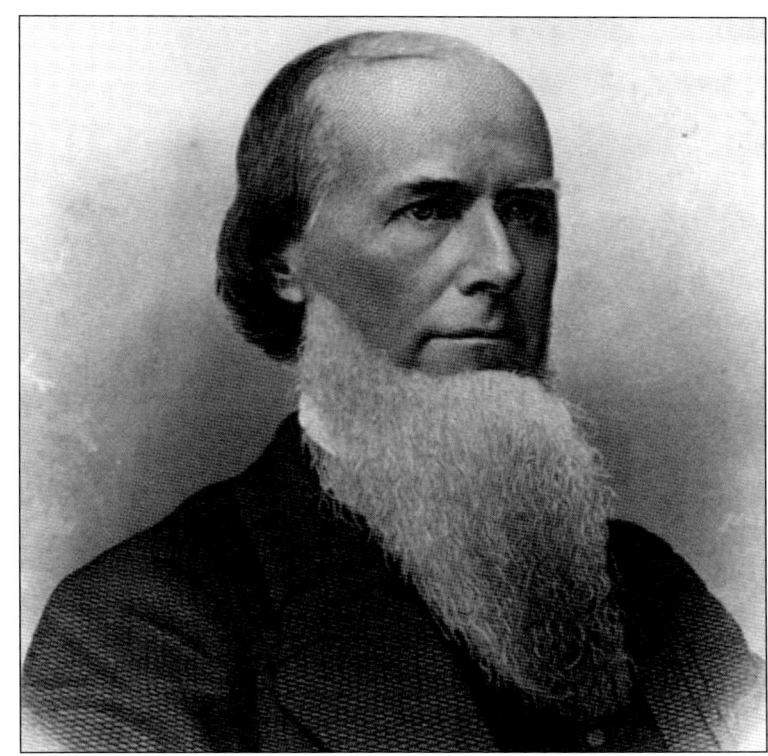

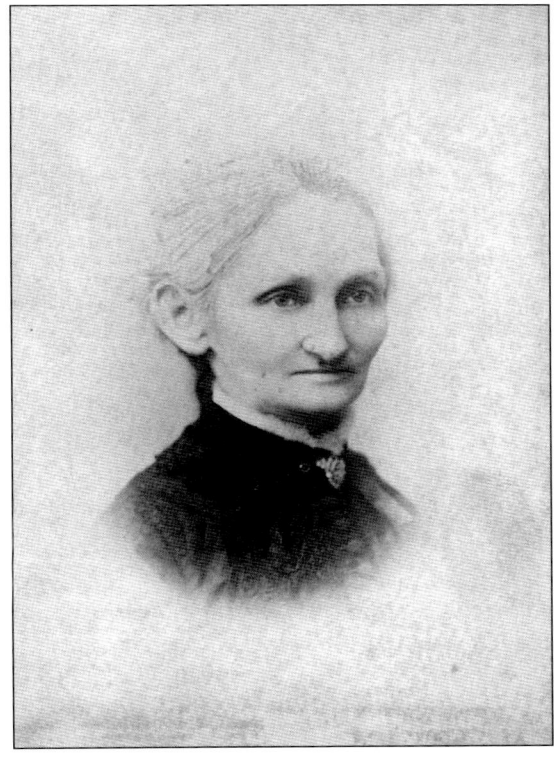

Elizabeth Grisham Brown, whose father was a Baptist minister in South Carolina, married Joseph Emerson Brown in 1847 in what has been described as a lavish affair. She was the niece of founding leader of Canton William Grisham. She and her husband lived in their home on Marietta Street in what is now Brown Park from 1848 until they left for Milledgeville, the state capital at the time, in 1857, for Brown to be sworn in as governor to begin what would be four terms of service. (Courtesy of Nell Galt Magruder.)

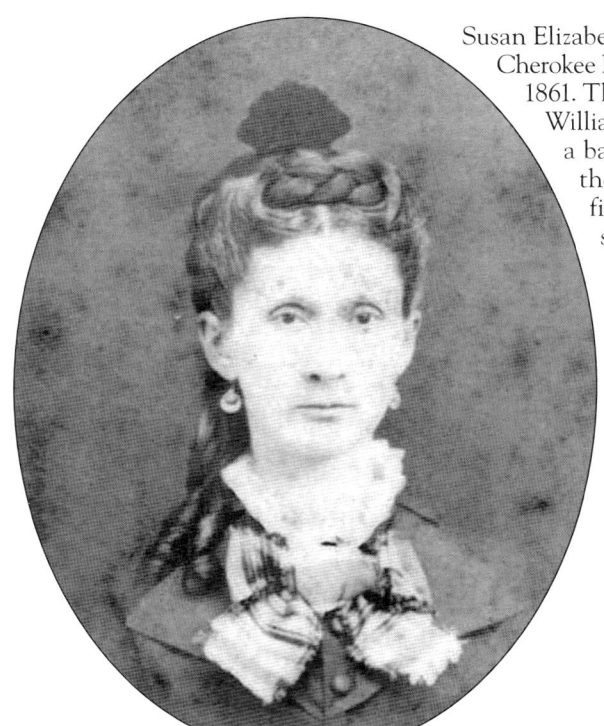

Susan Elizabeth Galt read a speech to the men in the Cherokee Brown Riflemen as they marched to war in 1861. The speech was written by her grandfather William Grisham. The men were also presented a banner to carry into battle, according to the speech. The Brown Riflemen were the first from Canton to respond to the call for service to the cause, and the company was named in honor of Gov. Joseph E. Brown, who was from Canton. The company of 100 men was under the command of Capt. Thomas E. Dickerson. The speech is on display at the Cherokee County Historical Society office in Canton. (Courtesy of Nell Galt Magruder.)

The Cherokee Brown Riflemen carried this banner, presented to them by Susan Elizabeth Galt, who spoke of the beautiful standard of colors prepared by the ladies of Canton for the gallant company of men. The banner now is held in the Chicago History Museum. It depicts a background of four mountains, a river, and a row of trees. In the foreground, a snake coils around a cotton plant. "Let me alone" is painted above the snake's head. (CCHS.)

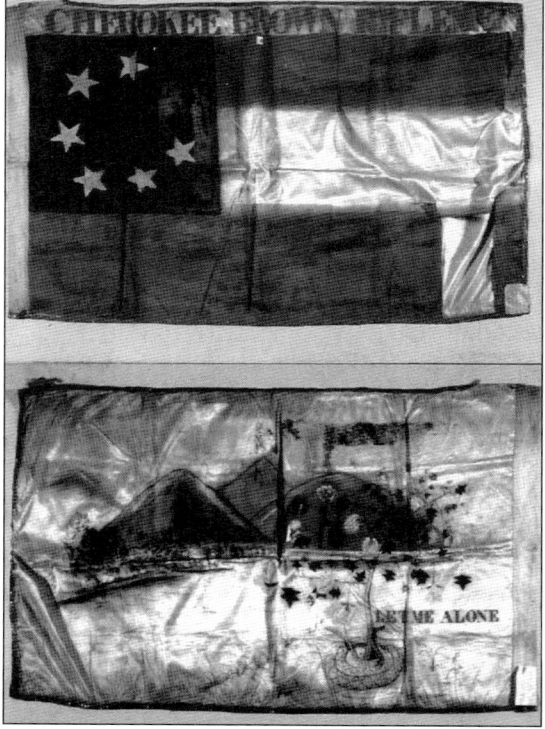

The Cherokee Dragoons flew this banner during the Civil War, and it is now at the Kennesaw Mountain National Battlefield Park Museum. The dragoons were Company C of the Phillips Legion Calvary and were commanded by Capt. W.B.C. Puckett. Puckett later served as a state representative from Cherokee County from 1877 to 1879. About 23 companies from Cherokee County enlisted during the war, providing about 1,800 soldiers from Cherokee County for the Confederacy. The flag is made of silk and hand embroidered with roses, made by the ladies of Cherokee County. The motto "Either With it or Upon It" is embroidered on it. (CCHS.)

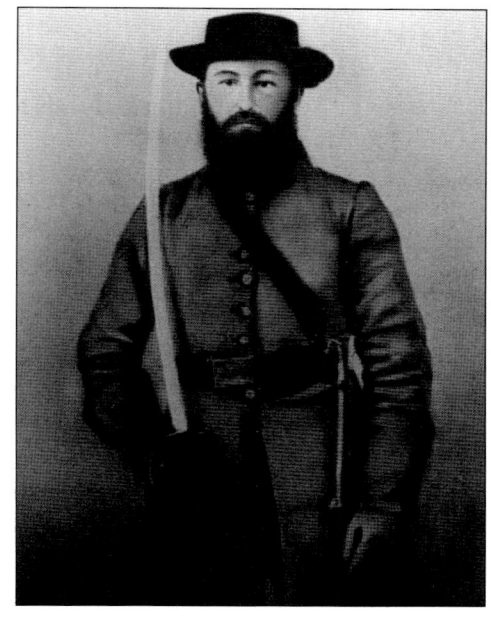

Alfred Lowe was a Confederate soldier who was killed during the war while on leave. According to a family account in the *Heritage of Cherokee County, Georgia 1931–1998*, he was bushwhacked, killed, and buried in Gilmer County as he was on his way back to the Confederate army in Virginia after visiting his family. He is listed as having served in the Cherokee Dragoons as a private. (CCHS.)

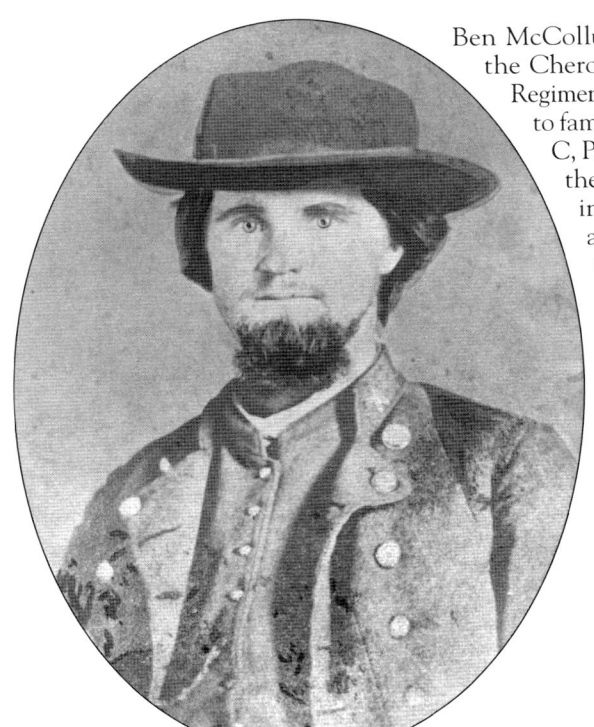

Ben McCollum from Cherokee County enlisted in the Cherokee Brown Riflemen, Company F, 2nd Regiment Georgia Infantry in April 1861, according to family accounts. He later served in Company C, Phillips Legion. Later in the war, he became the leader of Joseph Brown's home guard unit in Cherokee and Pickens Counties, known as McCollum's Scouts. Their charge was to hunt down Union sympathizers and make sure they were not able to aid the Federal troops under the direction of General Sherman who were fighting in the area and do what they could to thwart Sherman's troops. (CCHS.)

The Keith Plantation was one of the largest near Canton, encompassing 3,000 acres. After the end of the war, some of those who were slaves remained in the area north of town and became leaders in establishing a community of freemen, offering an education to children there and building up a church. Aggie Keith (left), pictured here in the late 1800s, was a slave on the Keith property. Three of her four children were born into slavery, and her son Amos, standing next to her, was born in 1866. (CCHS.)

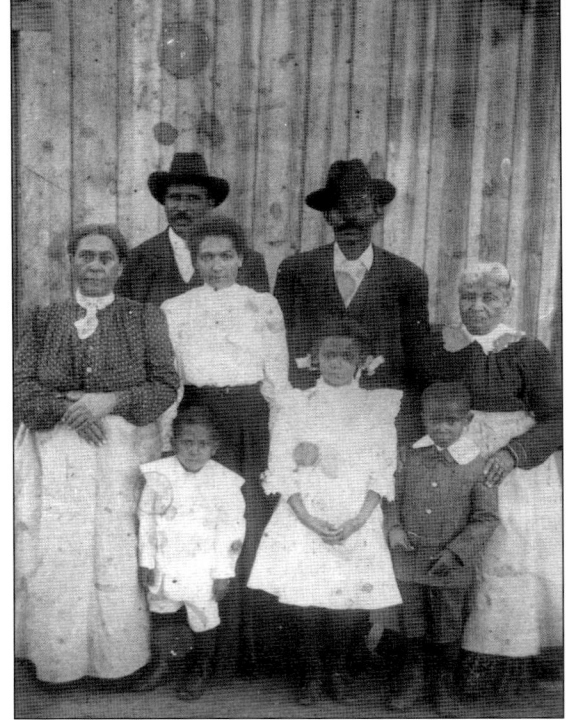

Judge James Rice Brown (1827–1915) was the brother of Georgia governor Joseph Emerson Brown and lived on the property known as the Brown Farm. James Brown was assisted, as his brother was, in obtaining an education at Yale University by Dr. John W. Lewis, wealthy pioneer physician of Canton. In 1856, James married Dr. Lewis's daughter, Harriet Frances Lewis (1836–1889). In addition to being a wealthy landowner, James was influential in politics like his brother and served as a state senator and judge of the Blue Ridge Judicial Circuit. After his first wife died, he married Mary Reynolds Walker (1857–1936) in 1892. (Author's collection.)

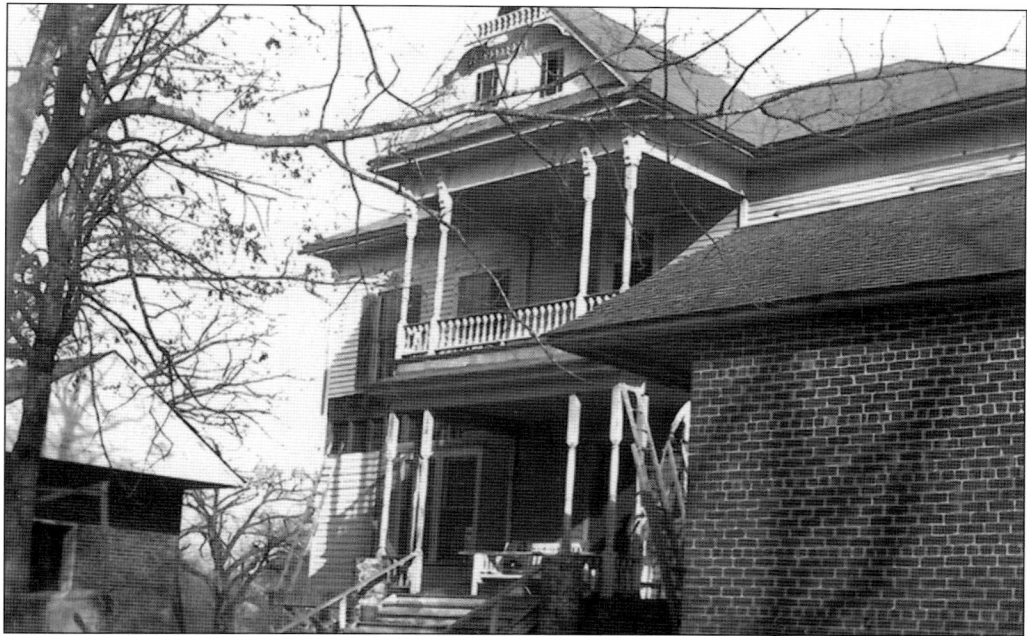

The Brown House, as it became known, was built by Dr. John Washington Lewis, one of the earliest settlers of Canton, a prominent doctor and lawyer believed to be related to George Washington. The residence was built from 1838 to 1840 and is still in use as a home today. Judge James Rice Brown married Lewis's daughter, Harriet Lewis, and came into possession of the house through her. He remodeled it in the 1890s, redoing the porches and columns. (CCHS.)

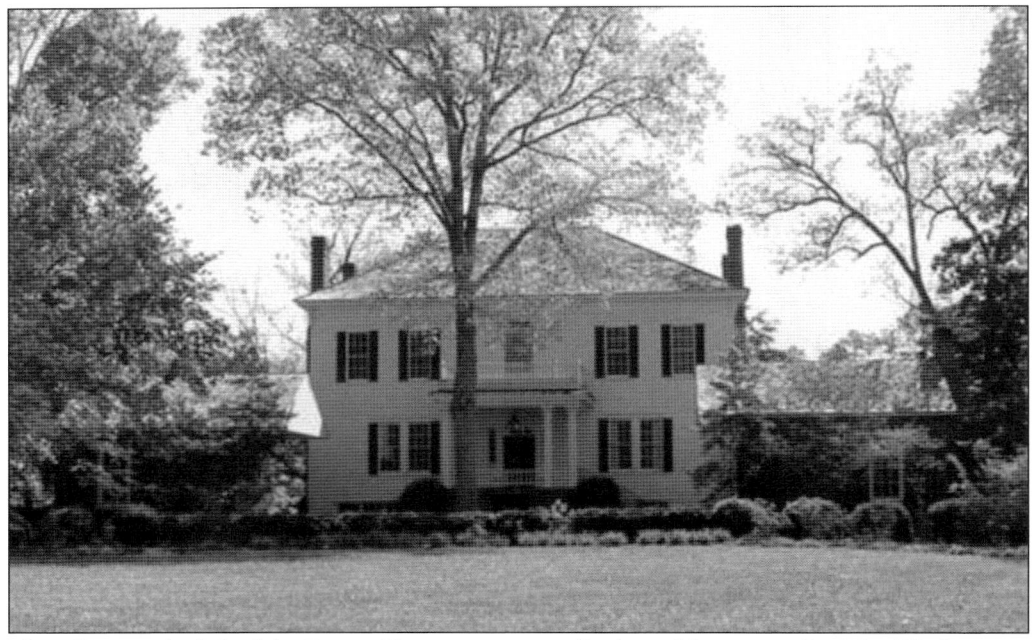

The office on the left of the Brown House was originally that of the owner, Dr. John Washington Lewis, and the one on the right was the overseer's. Lewis had a brick kiln, and the bricks in the outbuildings were handmade. There were other outbuildings at one time, including a buttermilk house, smokehouse, and spinning and weaving house. (CCHS.)

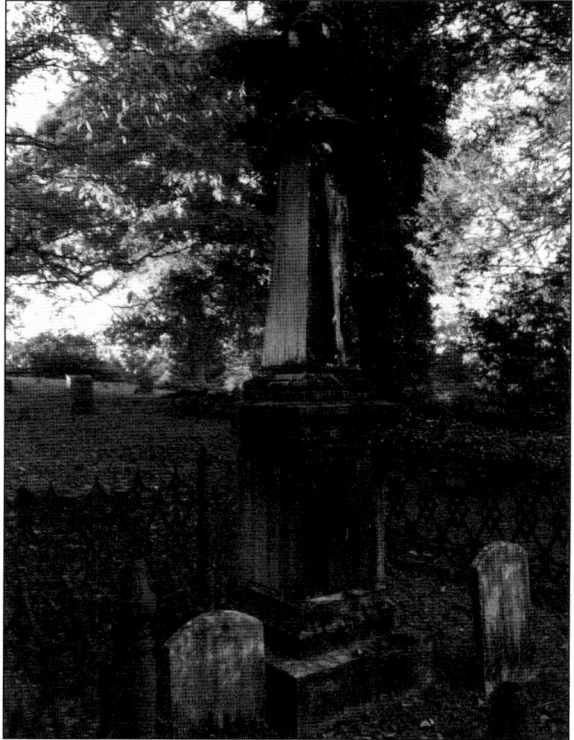

Dr. John Washington Lewis and his wife are buried in Riverview Cemetery in Canton. Lewis was one of the early settlers of Canton and was instrumental in bringing Joseph Emerson Brown and his brother, James Rice Brown, to Canton. A wealthy landowner, physician, and preacher, Lewis helped Joseph Emerson Brown borrow enough money to attend Yale University and study law. He graduated from Yale in 1846. (Author's collection.)

In the 1950s, when the Jones family lived at the house, a column was built from old brick found on the site, and the bell that had been at the Canton Methodist Church was installed as a farm bell. The outbuildings were constructed of bricks made from local clay. (CCHS.)

Frances Brown, daughter of Mary Reynolds Walker and James Rice Brown, grew up on the Brown Farm and became an accomplished young lady. According to a letter from Elizabeth Coggins Jones, Frances told her about a log house on the property that once was a Native American "pow wow house." (Author's collection.)

37

The heirs of Gov. Joseph Brown gifted to the city the property where his home in Canton stood before it was burned by Sherman's troops. On July 14, 1906, the park was dedicated by members of the Brown family at a celebration. In an article in the *Atlanta Constitution*, the event is called "quite elaborate . . . witnessed by one of the largest gatherings Cherokee County has witnessed in years." Heirs included his sons and daughters Mary Connally, Sallie Brown, George M. Brown, and Elijah Brown. Governor Brown's brother Judge James Rice Brown is in the hat. Many of the outbuildings of the home, including the kitchen, still stood at the time. A marble marker was erected at the time of the dedication. (CCHS.)

Some young people enjoy time in Brown Park, perhaps a Fourth of July celebration or the dedication of the park in 1906. Identified are (second row) John Scott (left) and his sister Mrs. Lowe Worley (second from left); (first row) from left to right, Mollie Scott, Meg Coggins, and Miriam Vaughn. The others in the photograph are unidentified. The straw boater hats were popular during the Victorian era. (Courtesy of R.T. Jones Library.)

On August 23, 1883, one hundred Confederate veterans from Cherokee County who served in the 23rd Georgia Regiment decided to hold a reunion in Canton. The men made it an annual event and elected John J.A. Sharp as president. In the next few years, other regiments held reunions, and as the numbers of living veterans declined, the Ex-Confederate Association of Cherokee, headed by Capt. H.W. Newman, a Canton lawyer who served in the war, continued to grow. Pictured here is one of the reunions in Canton. (Courtesy of R.T. Jones Library.)

Hezekiah Wilbanks moved to Cherokee County in the mid-1840s, joining his brother Thomas Wilbanks and uncle Hosea Wilbanks. They settled where Wilbanks Industrial Park is today. Hezekiah served in the Civil War in Company C of the Cherokee Legion, Georgia State Guards, under the command of Col. James E. Rusk from July 1863 until January 1864. (Courtesy of Lisa Fowler Phelps.)

John Beavers, here with his wife, Mary, about 1913, served in the Civil War as a private in Company D, 28th Georgia Infantry, the McAfee and Donaldson Guards. A farmer from the community of Buffington, he enlisted at age 23 on February 27, 1862. He was one of 65 privates to serve in the division under Capt. Nehemiah J. Garrison. The McAfee and Donaldson Guards were made up mostly of Canton men who knew one another, including Beavers's brother, William Beavers. The Cherokee County Historical Society has a collection of about 50 letters written by Beavers while he served in the war. The first major battle fought after he joined was the Battle of Seven Pines near Richmond, Virginia. He was later stationed at Fort Sumter and in the Charleston area. (CCHS.)

Three

CHANGING TIMES

This early Canton band is pictured here about 1900. The usual instrumentation of a Dixieland band was trumpet (or cornet), clarinet, trombone, piano, string bass (or tuba), drums, and banjo (or guitar). Canton was popular in the 1880s and 1890s as a summer resort, bringing in visitors to the area who could patronize the hotels and attractions of the city where entertainment was offered. (CCHS.)

George Washington Chamlee (1840–1923) and his wife, Malinda Robertson Chamlee, were among some of the earliest settlers of the area. George was born in Cherokee County in a cabin vacated by the Cherokee removal. The family home and gristmill were located on Chamlee Creek, which was later named Hickory Log Creek. Gristmills were powered by wooden waterwheels, grinding wheat or corn between the millstones. (CCHS.)

This Victorian home, the Brady house, stood where Waleska and North Streets meet today. Perhaps it was the residence of the Rev. John W. Brady, who served in the Confederate army as a chaplain. It is representative of many of the fine homes in Canton built in the late 1880s. (CCHS.)

Thomas M. Brady moved to Cherokee County in 1891 and founded a marble finishing company located at the end of West Main Street, which later became known as Georgia Marble Finishing Company (pictured). Brady's most famous work is the *Lion of the South* at Oakland Cemetery in Atlanta. Georgia Marble Finishing Company was purchased by R.T. Jones Sr. following Brady's death in 1907. (CCHS.)

This elaborate monument stands over the burial site of the Thomas M. Brady family. His son, Thomas M. Brady Jr., also buried here, was the first soldier from Canton and Cherokee County to be killed in World War I, and the American Legion Post No. 45 in Canton is named for him. (Author's collection.)

Georgia Marble Finishing Works, pictured in the foreground, was started on Railroad Street by the river about 1891 by Thomas M. Brady, and it was Canton's first major industry. Wide attention was focused on his company in 1894 when he secured the contract to make *The Lion of the South*, a memorial to Confederate soldiers. It was carved from the largest single block of Georgia marble ever quarried at that time. (CCHS.)

Thomas M. Brady Jr. is buried in his family's cemetery plot at Riverview Cemetery in Canton and was the first soldier from Canton to die in World War I. His father established a successful marble finishing company in Canton. (Author's collection.)

44

The Cherokee Marble Works was located in Canton and part of a thriving industry dedicated to finishing stone quarried in northern Cherokee and Pickens Counties and shipping the finished marble throughout the world in the late 1800s and early 1900s. James McClain, who later served as Canton mayor, is second from the left. (CCHS.)

Started by Frank Coggins, the Coggins Marble Company was on the opposite side of the railroad from Continental Marble in the area that is now Longview Drive. Coggins Marble was opened in the early 1900s, and the mill was destroyed by fire in 1914. The business was quickly rebuilt and stayed in operation until about 1928. Coggins was one of the most successful marble finishing owners, with four mills. (Author's collection.)

Cherokee County has had five courthouses, with the one on this postcard the third, a brick building constructed in 1874 on the site of the old courthouse in the central park facing Main Street. The brick courthouse built in 1840 was burned in 1864 by Sherman's raiders. Until this structure was built, court took place at the old Presbyterian church. This courthouse stood and served for about 54 years until it too was destroyed by fire, on March 5, 1927. The hotel burned on Christmas Eve 1919. (Courtesy of Nell Galt Magruder.)

In the late 1800s, Canton was a small agricultural community and a summer resort. The town featured several hotels to take care of summer guests who arrived by train to enjoy the cooler weather the area offered north of Atlanta. The Webb House or Webb Hotel was an establishment on Main Street near the county courthouse, perhaps where the Central Hotel was later located. (Courtesy of Nell Galt Magruder.)

Ben Kilby (left), Max Crisler (center), and Dr. John Turk are pictured here in one of the general stores in downtown Canton. Crisler was born in 1893, the son of Emma McClure Crisler and Benjamin Franklin Crisler, who in 1870 established B.F. Crisler and Son and became one of Canton's most influential businessmen. (Courtesy of Nell Galt Magruder.)

This Victorian home stood at Crisler and East Main Streets on the lot where the Academy of Dance Arts is located today. The Crisler family, including Benjamin F. Crisler and his son, Benjamin Roy Crisler, were prominent in the mercantile business in Canton with B.F. Crisler and Son. Benjamin F. was on the first city council of Canton. (CCHS.)

Rev. Milton B. Tuggle was pastor of the Canton Baptist Church in 1868, 1870, and 1875. He was married to Susan Elizabeth Galt and they had two children, May and Sarah Tuggle. The years after the Civil War were hard ones for the community, but the church continued to thrive and served the needs of the local Baptist congregation. (Courtesy of Nell Galt Magruder.)

Sarah Tuggle, the daughter of the Baptist minister who served at Canton First Baptist in the years following the Civil War poses in what might be her wedding dress. The detailing of the dress places it around the late 19th to early 20th centuries. (Courtesy of Nell Galt Magruder.)

This collage of deacons and pastors of the First Baptist Church was produced about 1897. The pastor of the church at the time was A.B. Vaughn, and he served in that capacity from 1886 to 1898 and again from 1899 to 1902. He is pictured in the center. Starting at the top are, clockwise, deacons George Washington Brooke (chairman), Judge A.C. Conn, R.T. Jones, Jabez Galt, and Dr. T.W. Hogan—all among the most prominent men of Canton at the time. Hogan was Canton's first dentist. (CCHS.)

The Rev. A.L. Harris was minister of the Canton Methodist Church in the early 1900s. He is pictured here with his wife, Hope Harris. They resided in the Methodist parsonage from about 1906 to 1908. (Courtesy of Nell Galt Magruder.)

49

The coming of the railroad to Canton in 1879 opened the city to new economic and societal opportunities. By 1884, four trains a day were running to the town, and the Canton Depot was a busy place as the marble industry boomed. Canton became known as a resort area with several hotels for travelers. (Courtesy of Nell Galt Magruder.)

Workers pick cotton around 1900 in a field on the Galt property. Canton Cotton Mill, which purchased much of the cotton grown locally, can be seen in the background shortly after it opened its doors in 1899. The rich land along the river yielded a good crop of cotton, helping Canton to be a thriving agricultural center. (CCHS.)

This postcard from the early 1900s shows the Canton Depot, which was a pivotal facility for the growing town. Marble finishing works and the new Canton Cotton Mill depended on the railroad to reach customers and bring in raw materials. The depot was torn down in the 1980s. (Courtesy of Nell Galt Magruder.)

Students pose outside Etowah Institute on Academy Street in 1894. The class includes Roscoe Spears, fourth from the left in the front row, with the darker collar, and Tom Curtiss, to Spears's right with the white collar. Thomas Brady is the boy in the first row with the white shirt and cap. Chet Teasley is the second boy from the right in the front row standing. Walter Spears is behind him and is wearing a boater hat. Frank Coggins is the third boy from the left in the center second row. (CCHS.)

Gainesville Street, now part of East Main Street, veered right off of Main Street and was home to many fine houses in the late 1800s and early 1900s. The two-story home is the McAfee house, which was where the Cherokee Elections Office is today. The home was built by Capt. Joseph M. McAfee for his daughter, Fannie, who married George Brown, son of Judge James Brown. (Courtesy of Nell Galt Magruder.)

Thomas Hutcherson Jr. (1865–1901) was from a pioneer family from Virginia who settled in Salacoa. He married Fannie Teasley (1870–1921). Hutcherson was admitted to the bar as an attorney in 1890, won the seat of state representative in 1894, and was solicitor of the Blue Ridge Circuit until his death. This home was perhaps located on Main Street, but the exact site is uncertain. (Courtesy of R.T. Jones Library.)

Burton Franklin "Frank" Coggins opened the B. Frank Coggins Mercantile store in 1906. The store on the left is Palmer Hardware, which was opened in the early 1900s by Frank Palmer and his brother Charles. Coggins was also active in the marble industry and served as director and on the executive committee of Georgia Marble Company. His store was on Main Street where the Haven Theatre was later opened in 1911. The Teague steam-driven sawmill is parked in front of the store in this pre-1910 photograph. (CCHS.)

Capt. Joseph M. McAfee came to Canton shortly after the Civil War and became one of the businessmen to lead Canton forward in the new era following Reconstruction. He opened a mercantile company and was active in farming, milling, ginning, and building. In 1874, he constructed a brick hotel, the Central Hotel, next to the courthouse. This building may have been on that spot prior to 1874 and possibly used as a hotel. (CCHS.)

In 1879, thirty-year-old Robert Tyre Jones moved from Covington in Newton County to Canton. He had studied at a business college and worked on his family farm before relocating his family to Canton. Within two decades, he would become the most influential and prominent businessman in the community, with holdings in banking, the marble industry, and the mercantile business. He was also the founder of Canton Cotton Mill. (CCHS.)

Taken from the east, this early photograph of Main Street shows the town as it appeared about 1910. Jones Mercantile is thought to be the store on the left, but the older building was replaced in 1914 with a new structure that has graced downtown since that time. The street was unpaved, and Canton was a horse-and-buggy town, which had a population of 2,500 in 1908. (CCHS.)

Robert Tyre Jones Sr. (1849–1937) came to Canton in 1879, the same year the railroad line was opened to the town. His first local business was Jones Mercantile Company, which for almost 100 years would serve Canton as its premier retail establishment. In 1899, he founded Canton Cotton Mills, which grew to be the main employer in Canton and produced Canton denim until it closed in 1981. Jones became the city's premier businessman and civic leader, involved in marble finishing, banking, and politicking, as mayor of Canton. He was president of the Bank of Canton, owned the Hotel Canton, and purchased Georgia Marble Finishing Works. (CCHS.)

Susie Walker Jones (1856–1899) was the first wife of R.T. Jones Sr. and moved to Canton from Newton County with her husband in 1879. She and R.T. had 11 children, four of whom died in infancy. Susie died just months before the opening of Canton Cotton Mill. (CCHS.)

Jones Mercantile Store was founded in 1879 by R.T. Jones Sr., who 20 years later founded Canton Cotton Mills. The store was the centerpiece of downtown and provided a shopping haven first as a general store and later as a department store. Jones Mercantile celebrated its 35th anniversary in business in 1914 with a sale and celebration. With savings of $3,000, Jones opened the store in 1879, and he quickly made a name for himself among the farmers and townspeople. (CCHS.)

Construction of the first Canton Cotton Mill, known as Mill No. 1, was begun in 1900, and it was built from local bricks made with clay from the banks of the nearby Etowah River. It had a marble foundation given by Thomas M. Brady, one of the company's shareholders. The mill was situated near the railroad tracks, and mill housing was built close by. (CCHS.)

This photograph was taken in the earliest years of the Canton Cotton Mill on Railroad Street. R.T. Jones founded the mill in 1899 with a subscription to raise capital to build the mill. By January 1900, the site was selected and construction began. In March 1901, the machines began to run and the first bale of cotton was processed; by April, the operation employed 125 people. (CCHS.)

The R.T. Jones family—including the patriarch, his children, and grandchildren—were leaders in a number of businesses in Canton for almost a century. Family members were active in church and civic affairs. Annual gatherings such as this 1908 Christmas dinner would bring them together in R.T.'s Victorian home, which sat where the Cherokee Justice Center now stands. Family members include, clockwise from left, Robert Permedus Jones, Clara Thomas Jones, Bobby Jones, P.W. Jones, Mary Foute Jones, Sue Jones, Rube Jones, Louise Jones, Lil Coggins Jones, Eleanor Jones, R.T. Jones Sr., Jim Cross, being held, Jack Jones, Louis Jones Sr., Albert Vaughn Jones, May Reynolds Jones, Emily Foster Jones Brooke, and George Brooke. (CCHS.)

The third floor of Jones Mercantile Company housed the furniture department. In this photograph taken in the early 1900s, the extensive array of furniture available reveals why the store was so popular with residents throughout North Georgia. Almost every home in Canton contained some piece of furniture bought at Jones's store. (CCHS.)

Jones Mercantile Store in Canton offered everything a family would need. Started in 1879 by R.T. Jones, the store sold everything from food and seeds to hardware, coal, and furniture. This photograph from the late 1920s shows some of the employees of the grocery area of the store. (CCHS.)

R.T. Jones joined the Canton First Baptist Church in 1879 and was selected as a deacon in 1881. He was Sunday school superintendent for 49 years and taught a Sunday school class, which was named for him. One of the classes is pictured here in front of his home. (CCHS.)

This postcard of the south side of Main Street shows the Bank of Canton, which was founded in 1892, before its renovation in the 1920s to add a marble facade. The bank was founded by a number of Canton businessmen, with the help of an outside banker, William Witham. Local founders included Robert Tyre Jones, William Teasley, George Teasley, J.M. McAfee, and others. (Courtesy of Nell Galt Magruder.)

The Bank of Canton was established in 1892 as the first financial institution in Canton. It officially opened its doors on December 21, 1892, and about 50 leading residents of the community put up the capital for the bank. The bank building on Main Street was remodeled in 1924 to add the marble facade that became symbolic for the bank during its more than 100 years in business. (CCHS.)

The Teasley home stood on Main Street at the corner of Brown Street and was built in 1892 by George Isham Teasley (born 1859). He was a prominent attorney, admitted to the bar in 1881, and also served as county school commissioner, Canton mayor, and council member. Teasley owned the largest orchard in the county, and his home was demolished in 1969 to make way for the connection of Main Street to North Street. (CCHS.)

The wedding of Emma Ellis to Jess Johnston drew a crowd to the Ellis Hotel in downtown Canton. The hotel, owned by Emma's father, was on Marietta Street where the Canton Police Department is today. Pictured here, from left to right, are Mr. and Mrs. Sam Cobb, three unidentified people, Myrtle Brook, three unidentified people, Lecy Galt, the bride, unidentified, Rev. L.T. Reed (pastor of Canton First Baptist Church, who married the couple), unidentified, the groom, Mrs. G.B. Johnston, Mrs. Eugene Campbell, Sam Dupree, Bell Tharpe, Odelle Tharpe, a Mr. Moore, unidentified, Pocahontas Garrison, Charlie Palmer, Mr. and Mrs. Joe Johnston, Mrs. Charlie Palmer, Ella Galt, Mrs. J.M. Bates, W.M. Ellis (hotelier and store owner), Dr. J.M. Bates, and Mr. Westerman. The children seated on the steps are, from left to right, Bryant Hasson, Martha Galt, Ellie Cohn, Frances Galt, Mary Berry Cobb, and Hattie Cobb. (Courtesy of Nell Galt Magruder.)

Young ladies of Canton enjoy a stroll and some time outdoors in this photograph taken in July 1886. Pictured here, from left to right, are Emma Ellis Johnston, Bessie Brooke Johnston, unidentified, Lecy Putnam Galt, and unidentified. (Courtesy of Nell Galt Magruder.)

Four

NEW DIRECTIONS

Baseball was a popular sport in Canton. This Canton team in the early 1900s includes Louis Jones Sr. and A.V. Jones. Albert Jones was the pitcher in 1908, and an article in the *Cherokee Advance* from June 5, 1908, notes that "Albert Jones pitches swell ball for the home boys and held the Roswell team in the palm of his mighty arm at all stages of the game." (CCHS.)

Two dozen mules were bought by Cherokee County in 1909 to be used with convict labor to build new roads. The mules, lined up in front of the courthouse, were purchased from Coggins and Brothers in Canton for $500 per pair, according to an article in the *Constitution* newspaper on April 1, 1909. The Central Hotel is visible to the left, but it was later torn down to make way for the Hotel Canton. (CCHS.)

Burton Franklin Coggins opened B.F. Coggins Store in 1906, and he built a three-story store that eventually became the site of Etowah Manufacturing in 1923. It was said Coggins planned to compete with Jones Mercantile store, but eventually he merged his business with Jones's and the store became the Jones-Coggins Department Store. (CCHS.)

This overview photograph of Canton taken from near Crescent Farm in the late 1920s shows the iron or steel bridge over the Etowah River. The mill village for Mill No. 1 is visible in the background. The white marble Cherokee County Courthouse can be seen in the upper left corner. (Courtesy of *Cherokee Tribune*.)

Canton got running water and electricity in October 1908, after the city built a water and light plant. This photograph was taken around the time electric streetlights arrived. According to an article in the *Cherokee Advance*, the streets in Canton were paved in 1926. (Courtesy of Nell Galt Magruder.)

The Fincher Drug Co. was started in 1900 by R.O. Fincher and William Wesley "W.W." Fincher (1876–1959). W.W. was the druggist and also served as mayor of Canton. This photograph from the early 1900s shows, from left to right, Roy Beard, unidentified, Will Hugh Hudson, Grady Cagle in front of bicycle, Dr. John T. Pettit, Waleska police chief Dave Guyton, W. Lester Ponder, Dr. Grady Coker, W.W. Fincher, Howard Bagwell, and unidentified. At the corner of Main Street and Church Street, the drugstore became an icon of the town, and the name was changed to Canton Drug Co. in 1912. W.W. sold the drugstore in 1918 to Charlie Darnell but purchased it back in 1922. (CCHS.)

By 1921, Canton had a new modern Hotel Canton, a Chevrolet dealership, and a booming downtown. The four-and-a-half-story building on the right, the town's tallest, is Etowah Manufacturing Company, which made garments. At this time, cars had replaced horses and buggies, and the Chevrolet dealership is located in the building. (CCHS.)

Canton is under a blanket of snow along Main Street from Marietta Street. That portion of the street was lined with homes in the early 1900s, including the McAfee house at the end of the street, which stood where the Cherokee Elections Office is now located. The house was torn down in 1968. Several of the homes along the right side still stand and serve as law offices. (CCHS.)

In 1907, the last class of the Etowah Institute before the school became a public school was under the direction of Prof. W.P Martin (left). Members of the class include, from left to right, (first row) Mary Sue Lockhart, Willie Fincher, Inez Doss, Rhea Jarvis, Jack Jones, Steele Earnshaw, Esmond Brady, and John Galt; (second row) Flora Blackwell, Eunice Ragsdale, Mary Glenn Roberts, Betty Scott, Laura Quarles, Eula McClure, and Opal Wheeler; (third row) Max Crisler, Douglas McAfee, Bert Earnshaw, Bob Dupree, Cary Ragsdale, George Edwin Johnston, and Leonard Sampson; (fourth row) Virgil Puckett, Walt Quarles, Odie Galt, Vas Kell, Will Puckett, and Bill Galt. (Courtesy of Nell Galt Magruder.)

Nevada Garrison's music class in the early 1900s included students of all ages. Pictured, from left to right, are (first row) Lucille Coker Phillips, Eleanor Jones Reid, Edna Williams Fackler, Elizabeth Jones, Allen Cutts, Rachel Keith, Amanda Perry, Rowena Dorn Odum, and Willie Fincher; (second row) unidentified, Betty Coker Patrick, Pearl Sandow, Nevada Garrison, Marie Archer Teasley, Marjorie Johnston, and Louise Jones Wood. (CCHS.)

A class of second-and-third-grade students and their teacher at Canton Public School in the early 1900s are pictured here. Education was always a priority with the residents of Canton, who founded the city's first state-chartered school in 1833, only two years after the county incorporated. Before the public school was started, tuition schools were common. (Author's collection.)

The class of 1910, grades 8–9, of Canton public schools includes, from left to right, (first row) Tully Jo Johnson, Steele Earnshaw, Warren Cutts, John Galt, Ronda McClure, Eulalie Blackwell, Mary Love Babs, Agnus Coggins, and Edwina Teasley; (second row) Julia Curry, Rochelle McClure, Jane Galt, Malinda Roberts, Lucille Kirby, Esther Cutts, Martha Galt, Rhoda Acoth, and Arla McCarthy. (CCHS.)

71

Canton High School, which later became the Canton Grammar School, was built in 1914 on the site of the Etowah Institute and was the first accredited high school in the county. The lovely brick building on Academy Street housed all 11 grades of the public school. The school was built to accommodate about 300 students and had an auditorium. (CCHS.)

Canton High School had a long legacy of athletic success. Girls' basketball was a popular sport at the time, and this girls' basketball team from 1916 includes, from left to right, Lucille Coker, Rene White, Edna Williams, Elizabeth Archer, and Bertie Perry. (CCHS.)

The Canton High School men's basketball team for 1915–1916 is pictured here. From left to right are Fielding Dillard, Allen Cutts, Jack Hasson, Max McCanless, C. Judson Galt, Wilson Barton, William "Bill" Thomas, and Harvey Cutts. The school colors were green and gold, and teams were known as the Canton Greenies. (CCHS.)

Dr. John P. Turk was a prominent doctor in Canton and the son of Canton physician Dr. John M. Turk. Here, Dr. John P. Turk makes his rounds in a buggy in the Nelson area, where he was hired by Georgia Marble Company to be the company doctor and tend to the employees' medical needs. (CCHS.)

Dr. Newton Jasper Coker and his son Dr. Grady Newton Coker opened the first modern hospital in Canton and Cherokee County in 1923 in what had been the Jabez Galt house. Dr. N.J. Coker was chairman of the city board of education for seven of his nine terms, and he served the county board of education for 19 years. Dr. Coker is largely credited with the consolidation of the city-county school system. (CCHS.)

In 1914, the second church building of Canton First Baptist Church was remodeled. The front was altered to face Brown Park, and the church bell now pealed out its call to worship—a familiar sound in Canton—from the architecturally beautiful new tower. (CCHS.)

The Galt Building was constructed by the Galt family in 1924 and brought a distinct look to the corner of Marietta and Main Streets. The structure was sold by the Galts in 1947. Today, it is owned by Canton city councilman Bill Grant and known as the Grant Building. (Courtesy of Nell Galt Magruder.)

The Green family owned Green's Barber Shop in Canton, shown here in the 1920s, as well as the Green Rail Restaurant in downtown Canton and later the Pine Crest Restaurant. Customers and barbers crowd the shop on a busy day, including A.E. Martin, Edith White (in the back of the barbershop), Lester Smith, C.C. Haley, and C.J. Manous. (CCHS.)

Etowah Manufacturing Co. opened about 1926 and produced garments and later chenille bedspreads. It was located on Main Street in the building where B.F. Coggins's store was at one time and where Cantex was later located, before being destroyed in a fire in 1955. The downstairs of the building housed a car dealership at the time of the above photograph, perhaps in the late 1920s. The photograph below shows the inside of the building where the garments were made and prepared for delivery to customers. (Above, CCHS; below, courtesy of *Cherokee Tribune*.)

The Canton Glee Club, pictured here in 1924 on a visit to Atlanta, was under the direction of Martha Galt. The club was a popular pastime for young women of the day. Members included young women from the finest families in town. Pictured are, from left to right, (first row) Rochelle McClure, Daisye Crisler, Nevada Garrison, Martha Galt, Irene P. Rudasill, Lucille Coker, Amanda Perry, Clera Rudasill, Martha Delay, Pearl Sandow, and Frances Galt; (second row) Ida Christy, Nelle Michael Chamlee, Nettie Groover, Orleans Humphries, Estelle Greene, Mary Bates, Nina Thompson, Rachael Keith, Mrs. George Doss, Mildred Martyn, Margaret Martyn and Berta McCox; (third row) Malinda Galt, Mary Foute Jones, Mrs. Charles Goodman, Ruth Pund McCanless, Viola Tooler, Ernet Hogan Conn, Erlyn Cobb, Jessie Deadwyler Winn, Mellie Harp Moody, and unidentified. The building is believed to be the Fox Theater. (CCHS.)

Daisy Ryman Coggins and Augustus "Gus" Coggins take a ride in an ox-drawn buggy. The livery barn was located on North Street in Canton along the street where the white marble courthouse now stands. Daisy was the daughter of the owner and operator of Ryman Steamboat Company in Nashville, Tennessee, and married Gus in 1894. (CCHS.)

Augustus Lee Coggins (1868–1952) was a controversial figure, a successful mule trader who rose to great heights in Canton and the state as a breeder of race horses. He owned Crescent Farm, which included the Rock Barn and Edgewater Hall. Many of his earlier barns were burned, possibly because he hired African American workers, leading him to construct his barn from rock. Coggins left town suddenly in 1926, bankrupting the Bank of Cherokee. (CCHS.)

Coggins's mule barn and livery stable in downtown Canton was on Main Street. Gus Coggins ran a successful mule trading business. The barn was remodeled in 1927 and turned into an agency for Hudson and Essex automobiles, and it became a Chevrolet dealership in the 1930s. The building was where Chamberhouse was later located. Coggins also owned the Bank of Cherokee and moved suddenly to Missouri in 1926, leaving angry depositors at the bank to have to petition the court to try to get their money. (Courtesy of Cleveland Chambers.)

In 1922, Augustus Coggins built his family home, Edgewater Hall, at Crescent Farm. The Georgian Revival home was constructed from brick and designed by Atlanta architect Francis P. Smith. Crescent Farm was known in racing circles for its horses, the most famous of which was Abbedale, a world-class pacer, who is listed in the Harness Racing Hall of Fame in Goshen, New York. (CCHS.)

Crescent Farm Stable, now known as the Rock Barn, was built in 1906 by Augustus Coggins after several of his wooden barns mysteriously burned to the ground. The first fire was in 1900, and Coggins's racehorse Queen Nab, one of the most famous horses in the state, died in the blaze. The rocks used to build the new barn were dug from the Etowah River nearby. (CCHS.)

The Gus Coggins Band, a Dixieland band pictured here about 1914, includes performers, from left to right, Zet Walker, William Walker, Jag Reid, Gus Green, James Wynn, Dough Wynn, George Reid, Snag Williams, Will Elrod, Will Green, and Homer Woods. Standing are, from left to right, Gus Coggins; Jack Bark, the music director; and K.L. Moss, the farm manager at Crescent Farm, where the photograph was taken. (CCHS.)

Construction on the white marble courthouse in downtown Canton was begun in 1927 and completed in 1929. The courthouse cost $150,000 to build and was designed by A. Ten Eyck Brown. Eugene A. McCanless was chairman of the committee to build the courthouse and as president of Georgia Marble Finishing Works in Canton, instrumental in providing white marble for the new facility. (CCHS.)

These two stately homes on Main Street in Canton were built in the late 1920s by father and son Eugene Augustus McCanless (1877–1958) and Edgar Maxwell McCanless (1898–1955). Eugene was the grandson of one of the earliest landowners in Canton, millwright William King McCanless. Eugene was president of Georgia Marble Finishing Works in Canton, associated with the company for 32 years, served as mayor of Canton, and led the effort to build the white marble courthouse in 1927. Edgar was mayor of Canton in 1921, a prominent attorney until his death, and served in the Navy during World War I. (CCHS.)

In 1923, a second mill was constructed for Canton Cotton Mills, across the river from the first factory, in what was known as North Canton. Mill No. 2 was completed in 1924, had 750 looms, and operated 23,000 spindles to manufacture Canton denim. (CCHS.)

Paul Walker Jones (born 1881) and his wife, Mary Foute Jones, lived in this home on Marietta Street on Brown Park. P.W. Jones was president of Jones Mercantile Company. The house was torn down in the 1980s to make way for a new post office, which was later converted into the Canton Police Department. (CCHS.)

R.T. Jones Sr. had four other mercantile stores in addition to the one in downtown Canton. The North Canton store (pictured), managed by Carl Edge, opened in 1928 and was on the northeast corner of the intersection of Waleska Highway and Ball Ground Highway. This early photograph was taken about 1930. (CCHS.)

Ramsey Colquitt Sharp was born in 1870 in Waleska. In 1928, he lived in Canton after being elected superintendent of schools, and he was reelected in 1932 for another four-year term leading the county's public school system, including Canton High School. Prior to that time, he served as president of Reinhardt College. (CCHS.)

83

This photograph was taken around 1928, and the steps of the courthouse that burned that year are visible on the left past the front of the hotel. The Bank of Canton's marble facade is visible on the right. Canton Drug Company anchored the south side of the street. (Courtesy of Nell Galt Magruder.)

James Walter Wheeler (standing) and two unidentified friends pose at a home on Main Street about 1930. Wheeler, the son of Henry and Belle Wheeler, grew up on Main Street, attended Canton High School, and went on to work for Canton Cotton Mills in managerial positions. (Author's collection.)

A Peace Day Parade on Main Street in Canton helped celebrate the end of the World War I in 1918. Here, young people march along Main Street in front of the Crisler-Greene house, which was later torn down. (CCHS.)

Members of the Helen Plane Chapter Daughters of the Confederacy helped to erect the white marble arch in Brown Park and held a celebration in 1923 to mark the monument's completion. "Their names may be forgotten but their deeds are recorded in the annals of their grateful country" is engraved on the monument. (Courtesy of R.T. Jones Library.)

In 1923, many of those who served from Canton and surrounding communities in World War I came to the dedication of the new white marble monument in Brown Park. Here, those being honored at the event leave the First Baptist Church and head to the park for the ceremony. (Courtesy of R.T. Jones Library.)

The inside of the Canton First Baptist Church was decorated and used in the celebration to mark the white marble monument in Brown Park. When it was erected and dedicated in 1923, the monument celebrated veterans of both the Civil War and World War I from Canton. Later, the names of veterans of World War II were added. (Courtesy of R.T. Jones Library.)

More than 500 men from Cherokee County served in World War I, the Great War as it was then known. Thomas M. Brady Jr., the son of Thomas M. Brady, the famous marble finisher, was the first among the 16 men from the county who died. Here, Canton war veterans pose in front of the monument in Brown Park when it was erected and celebrated in 1923. (Courtesy of R.T. Jones Library.)

James Arthur Sullivan (1875–1939), pictured with the city's fire truck, was named Canton's first full-time fire chief in 1932. The fire station was located on Main Street downtown in what is known as the Municipal Building. In 1933, firefighters for the city included, along with Chief Sullivan, A.F. Pearden, Joe Ponder, Henry Wheeler, D.T. Smith, W.W. Harbin, Ed Ledford, Buck Pope, Luke Ledford, Sam Hathcock, J.T. Harbin, George Wallenhaupt and J.A. Johnson. (Courtesy of R.T. Jones Library.)

Five
ERA OF PROGRESS

When the Cherokee County Courthouse on Main Street burned in 1927, a new marble courthouse was built in 1928 on the square, and the new structure served as the courthouse for almost seven decades. The material chosen for the new courthouse reflected the booming marble industry at the time and became an icon for the community. (CCHS.)

In 1923, construction began on Canton Cotton Mill No. 2 in North Canton, across the Etowah River from the town. The mill was completed in 1924 and had 750 looms and 23,000 spindles to increase production of Canton denim. The mill sat next to rich bottomlands where cotton was grown and Heritage Park is today. (CCHS.)

Emory Day, in the dark suit, oversees the weighing of cotton bales to be stored and used at Canton Cotton Mill in the 1930s. Much of the cotton used by the mill was raised locally, although cotton was purchased from throughout the United States for use at the Canton mill. (CCHS.)

Emmett Bishop was one of the cotton growers who provided Canton Cotton Mills with the necessary raw product. In 1948, when this photograph was taken, he had been growing cotton for 40 years and selling his entire crop to Canton Cotton Mills. His farm was north of Canton, and his father, Cheney Bishop, had also grown cotton and sold it to the mill. (CCHS.)

Cherokee County was among the top counties in Georgia in per-acre production of cotton, and railroad facilities made Canton one of the leading cotton markets in Georgia. After 1900, much of the cotton grown locally was used by Canton Cotton Mills. (CCHS.)

Pictured here are bales of local cotton being delivered to Canton Cotton Mill. When R.T. Jones, who was raised on a farm near Covington, moved to Canton, he quickly became acquainted with the local farmers. When Jones opened the mill in 1899, he began to purchase their cotton. (CCHS.)

Louis Lindley Jones Jr. was the president of Canton Cotton Mills for many years. He was R.T. Jones's grandson and worked as vice president under his father, Louis Lindley Jones Sr., until his death. Then the younger Jones assumed the reins and led the mill for many years. (CCHS.)

The Canton Cotton Mill office was built in 1929 and signaled a new era at the mills. By then, the two mills were operating and Canton denim was enjoying a growing reputation for excellence. On Main Street and was accented with marble, the office headquartered the management of the mills. (CCHS.)

This lumberyard in Canton was one of many businesses necessary to fuel the continual building boom in Canton in the years after the Canton Cotton Mill opened. Mill houses were being constructed at a rapid pace. The mill is visible in the background of this photograph. (CCHS.)

The Canton Pool was a popular part of the Canton Golf Course. The nine-hole golf course and swimming pool provided members with a fun place to spend leisure time. When this photograph was taken in 1949, the pool had just been painted. (CCHS.)

The Canton Golf Course was built on the edge of Town Creek by the Jones family, with help from famous golfer and family member Bobby Jones. The nine-hole course offered a challenge to local golfers, and the clubhouse was situated in a beautiful North Georgia setting on Golf Course Road. (CCHS.)

The Cherokee County Courthouse in Canton served as the centerpiece of the town after its construction in 1928. The area where the old courthouse that burned once sat was by this time a lovely park in the downtown area. Houses lined the street next to the courthouse that went to the First Methodist Church. (CCHS.)

Richard B. "Dad" Sims was the postmaster in Canton from 1941 to 1967 and one of the city's most beloved residents. He watched the post office grow from a third-class to a first-class facility. He came to Canton, along with his wife, Gertrude, in 1926 and assumed the duties of choir leader and educational director at First Baptist Church. (CCHS.)

This photograph shows construction on the Cherokee Sales Company Ford Building, which is on Marietta Street in Canton. The building still stands and is used as a church and offices. Griffin Roberts is pictured on the right. Many new businesses were erected in the early 1900s, as the town experienced unprecedented growth. (CCHS.)

Roscoe Spears (left) and Griffin Roberts constructed a redbrick one-story building on Marietta Street in 1917 for a Ford dealership. Here, the owners greet their customers in the parts department. The structure is now used as office space, but it is still known as the old Ford Building. (CCHS.)

The Standard Service Station was an affiliate of Main Street Garage and Canton Chevrolet Company across the street, and it was adjacent to the Hotel Canton in 1937. E.W. Keeter, Ernest Stone (manager), and Gene Holcomb operated the station, where Standard Oil products were offered exclusively. (Courtesy of Cleveland Chambers.)

Canton bought a fire truck in 1949 for the enormous sum of $7,000. Councilman Willie Hugh Hudson (right) was chairman of the city fire committee, and Gene Holcomb (left), an employee of Main Street Garage, handed over the keys. Police officer Sam Hathcock is seated in the truck. (CCHS.)

The Hotel Canton was built in 1921 after the Central Hotel burned, and it graced the downtown square for decades before it was torn down in the 1960s. The hotel was known throughout the region for its hospitality and hosted many social events, political functions, and organizations in its dining room. Visitors to Canton were impressed with the hotel's accommodations as well. (CCHS.)

The Hotel Canton provided a convenient location for out-of-town visitors right on the square downtown. The hotel was also used as a meeting place for civic organizations and business groups. An advertisement for the latest movie showing in town graces the wall of the lobby in 1946. (CCHS.)

A new Coker Hospital was built in 1933 by Dr. Grady Newton Coker (1894–1977) and his father, Dr. Newton Jasper Coker (1868–1939). They were prominent physicians, skilled surgeons, and civic leaders. Dr. N.J. Coker opened his practice in Canton in 1910 and established the first Coker Hospital in 1923 with the assistance of his son. The 1933 hospital was state-of-the-art at the time and served Cherokee County until the early 1960s when the R.T. Jones Memorial Hospital opened. (CCHS.)

In 1929, the Coker home was built on Jeannette Street in Canton by Dr. Grady N. Coker for his family. The two-story brick residence was built in the Colonial Revival style. Dr. Coker operated a free cancer clinic for years and was a pioneer in medicine in Cherokee County, along with his father. (CCHS.)

Paul Walker Jones (1881–1941), on the right, was the son of R.T. Jones Sr. and took an early interest in his father's enterprises. He was called "Mr. Paul," and under his leadership Jones Mercantile Company became a full department store. He was involved in numerous businesses in Canton, served as president of Main Street Garage and Canton Chevrolet, and enjoyed hunting. The man on the left is unidentified. (CCHS.)

Canton resident J.O. Garrett was one of those who served with distinction during World War II. He was a US Air Force major and pilot and flew B-24 bombers over Germany, Belgium, and France and trained other pilots. Garrett is pictured here in 1945 while stationed in England. (Courtesy of Betty Garrett Adams.)

Georgia Power Company employees in Canton gather in front of the R.T. Jones home in downtown Canton. The city power company was sold to Georgia Power in the mid-1930s, and this photograph was taken about 1935. Pictured, from left to right, are (first row) engineer Morton Doyal, salesman T.A. Mock, cashier Alma Matthews, and assistant Mary Lindsor; (second row) salesman Joe Wheeler, lineman Bill Thornton, district manager O.P. Galt, lineman Major Brown, cashier Evelyn Perry, and repairman Henst Gide; (third row) appliance repairman Louis Moss, unidentified man, cut-in/cut-out electrician Herbert Bennett, lineman Jack Linbog, foreman J.C Youngblood, local manager Jon Dowe, and appliance repairman Steiny Vansant. The R.T. Jones home was later torn down. (Courtesy of Nell Galt Magruder.)

Henry Hamby was a fixture at the *North Georgia Tribune* and later the *Cherokee Tribune*, where he set type. The newspaper was owned at the time by brothers Ralph Owen and C.B. Owen, who bought it from the Jones family in 1944. Canton had a number of newspapers over the years, including the *Cherokee Advance*, begun in 1880. The Brumby family bought the paper in 1973. (CCHS.)

Oscar Jordan and Clare Emerson pose for a photograph in the 1930s. Jordan lived on Crisler Street in the African American community known locally as Stumptown, and Emerson was a schoolteacher at the time. Stumptown was settled by former slaves following the end of the Civil War and named for the stumps left when houses were built. (CCHS.)

Stumptown was one of the African American communities in Canton that developed following the end of the War Between the States. One of the main thoroughfares of the area is Crisler Street, shown here in the 1940s. Stumptown maintained a commercial center for decades. (CCHS.)

The Canton High School band, pictured here in 1940, was a popular extracurricular activity for students at the school. Canton was known for its sports and other activities. It was the only accredited high school in the county at the time and offered a sound education for its pupils, the majority of whom lived in Canton, although many came from Woodstock and other parts of the county. (CCHS.)

As a part of the Canton Cotton Mills 50th-anniversary celebration in 1949, local school officials were invited to tour the mill with mill executives, including, from left to right, (front row) Louis Jones Jr., Jim Wheeler, Pierce Landrum, Bill Booth, Coy Free, Roy Johnson, and Eugene Owen; (back row) Elizabeth Bailey, Hal Clements, C.K Cobb, Charles Penny, Robert Strickland, unidentified, Leroy Tippens, Marion Tompson, Bill Hasty, and unidentified. (Author's collection.)

Jones Mercantile Company was a centerpiece of downtown Canton for decades. Next to it in this side view, the Victorian home of R.T. Jones is visible. The house was later torn down and a parking lot constructed that later gave way to the Cherokee Justice Center. (CCHS.)

These houses in the mill village on Lakeside Drive were completed about 1949 and rented out by Canton Cotton Mills to employees. Most of the houses had four or five rooms, although some were larger, with six rooms. The homes were in high demand. (CCHS.)

This woman in Mill No. 2 is working with the spindles that hold the thread visible behind her and the strands coming together to be woven into cloth. When the mill was completed in 1924, it had 23,000 spindles, but it had more than 40,000 spindles by 1949. (CCHS.)

In 1949, at the time of Canton Cotton Mills's 50th anniversary, John Williams was the employee with the longest continuous service. Williams had worked for the mill for 48 years and was a loom repair expert. Both mills had 1,400 looms at the time. (CCHS.)

A group of mill workers poses in Canton Cotton Mill No. 2 during the 50th-anniversary celebration of the mills. The new mill was constructed in North Canton and significantly increased the output of the company. Machinery was improved in 1936, and in 1935 the company was one of the first to put in a machine for fabric to be Sanforized. (CCHS.)

The 1948 North Canton School Rhythm Band gave students at the school a fun, creative outlet. Pictured here are, from left to right, (first row) Kathy Mauldin, Faye Edmondson, JoAnn Reinhardt, Carole Fowler, Sandra Green, Patsy Smithwick, Kertis Bramlett, Sue Ellen Payne, Melba King, Sue Payne, and Arlin Smith; (second row) Gladys Holcomb (teacher), Don Dover, Jimmy Mitchell, Brenda Reinhardt, Charlotte Gazaway, Bertha Cannon, Hazel Ellis, Frances Allen, Macky Whitmire, Charles Grover, and Jerry Weaver; (third row) Sara Jo Stephenson, Shelba Clark, Shelba Galloway, Betty Jean Lathem, Fayelynn Dobson, Gail Hathaway, and Nellie Owen (teacher); (fourth row) Eloise Satterfield and Peggy Roper. (CCHS.)

The boys' and girls' basketball teams at North Canton played under coach Lee Roy Tippens in 1950. The school was owned at the time by Canton Cotton Mills and located in the mill village. Pictured here, from left to right, are (first row) Peggy Nell Groover, Willie Jean Smith, Martha Jean Smith, Betty Vaughn, Barbara Loden, and Fonda Smithwick; (second row) Bobbie Ann Galloway, Jerry Ann Shadburn, Shirley Compton, Evelyn Morris, Clara Manous and Darlene Loggins; (third row) Charles Langston, Gerald Herring, Billy Whitmire, Jerry Carnes, Leon Cox, and Coach Tippens. (CCHS.)

Randall Bagwell provided fiber testing as a part of quality control for Canton Cotton Mills. In 1949, the mills employed 1,200 people in Canton. Quality control was an important step in providing Canton denim to the marketplace. The mill enjoyed a good reputation with its customers, many of whom bought Canton denim for 40 years or more. (CCHS.)

Robert Permedus Jones (1879–1956) was the eldest child of R.T. Jones Sr. and was born months before his family moved to Canton. He graduated from Mercer University in 1898 and the University of Georgia School of Law in 1899. He practiced law in Atlanta. After his father's death, he was named chairman of the board of both Canton Cotton Mills and Jones Mercantile Co. His son, Robert Tyre Jones Jr., was known as Bobby Jones, the famous golfer. (CCHS.)

More than 5,500 people attended a tour of the Canton Cotton Mills and a picnic at the Scout Hut to commemorate the mill's 50th anniversary in 1949. Pictured here, from left to right, are A.V. Jones, L.L. Jones Jr., Bobby Jones, Col. Robert P. Jones, and two unidentified men. At the time, the mill employed more than 1,000 workers. (CCHS.)

Canton Cotton Mills provided many avenues of recreation for employees, like the basketball team from the 1950s pictured here. The city's largest employer for most of the 1900s until it closed in 1981, the company had a school it maintained, including a gymnasium in the North Canton mill village. The school was later absorbed into the county's public school system. (CCHS.)

Ben Perry Jones was the grandson of R.T. Jones and served as personnel director for Canton Cotton Mills. Ben wrote a family history in which he reminisces about his grandfather. He notes that as a child he viewed his grandfather as stern, but that as an adult he saw him as a great leader and organizer. (CCHS.)

The McAfee house was located at the end of Main Street in Canton and was purchased by the R.T. Jones Foundation for $25,000 to house the public library in 1957. Built by Capt. Joseph McAfee, the structure was torn down and replaced with a new library in the late 1960s. That building now houses the Cherokee Elections Office. (CCHS.)

Cantex Manufacturing Company, which produced corduroy, took over in the Etowah Manufacturing building in the late 1940s. The building was destroyed in a fire a few years after Cantex opened. The spot stayed vacant for 54 years until a new office building was constructed on the site. (CCHS.)

Spectators watch from the steps of the Hotel Canton as firefighters and police work to control a blaze that destroyed much of a block in downtown Canton on June 29, 1955. The fire started with an explosion at the Cantex Manufacturing Company that killed one worker and injured several others. Fire units from throughout northern Georgia responded. Several cars parked in front of the hotel were destroyed or damaged. (CCHS.)

One man died and several where injured when the new boiler exploded at Cantex Manufacturing Company in downtown Canton. Within minutes, the fire had spread throughout the four-and-a-half-story building. There were 115 employees at work, but most escaped unharmed. (CCHS.)

The Cantex Manufacturing Company fire on June 29, 1955, destroyed or damaged several key businesses along Main Street, including the *North Georgia Tribune* office, Main Street Garage, and Yarbrough Brothers Grocery Store. Fire units from throughout North Georgia were sent to aid the city and try to stop the blaze. Many spectators stood crying in the street. (CCHS.)

Firefighters were unable to save the Cantex Manufacturing Company building in a tragic fire in June 1955, which also damaged several adjacent buildings. The fire was called the worst disaster that had ever struck Canton. The former Cantex location would stay vacant for the next 54 years, until a new office building was constructed on the site. (CCHS.)

Etowah Bank began operations in 1927 and occupied this building at the corner of Main Street and Church Street (shown here about 1950 after a remodeling) for many years. The bank had two original employees who were associated with it for years—N.A. Thomason (cashier) and N.E. Fackler (associate cashier). Thomason was with the bank 36 years; Fackler, for 45 years. (CCHS.)

For many years, parking meters lined the streets of downtown Canton. The Bank of Canton and the Canton Drug Company, which became a Rexall store, were two of the many businesses that provided continuity to the city. Shoppers came from all around to the downtown area, which continued to thrive. (CCHS.)

The original Rosenblum's store was located on East Marietta Street, and it was owned and operated by Si Rosenblum. The store was moved to East Main Street in the mid-1950s and continued to thrive there. The building pictured here was later torn down, but the building to the left now houses Downtown Kitchen. (CCHS.)

Traffic lights were installed along Canton's streets in the late 1940s as the city experienced more traffic. The Ford dealership is visible on the left in this photograph of East Marietta Street, which still looks much the same as it did 50 years ago. It no longer has a traffic light. (CCHS.)

Nancy Doss and Charles Cobb were two of the popular teenagers who attended Canton High School. The school served Cherokee County until 1956 when a new high school, Cherokee High, opened across the river, replacing the old high school, which became an elementary school. (CCHS.)

This photograph of senior class officers for the class of 1954 at Canton High School includes Joel Garrison (president) at the piano and, from left to right, Mr. Barton (advisor), Gene Moore (vice president) Hugh Thacker (secretary), and George Dick (treasurer). The city public school closed when Cherokee High School opened in 1956. (CCHS.)

Six
Coming of Age

Canton and the surrounding county celebrated the impact the poultry industry had on the community's economy with the Poultry Celebration on the Fourth of July in the 1950s. Sponsored by the Canton Jaycees, the Fourth of July event drew large crowds to the downtown area. The entertainment, like that pictured here on the steps of the white marble courthouse, had a local flavor. (Author's collection.)

Poultry was big business in Cherokee County in the 1950s and 1960s, with a number of processing plants and other related industries providing jobs and positively impacting the economy. Trucks carrying chickens from the surrounding poultry farms were a familiar sight, and the county became known as the Poultry Capital of the World. (CCHS.)

In North Canton, the Ralph Bunche School served the African American community. It was built in the 1950s to consolidate all elementary and high school students who were African American into one school. In 1967, the school was closed and all students were integrated into Cherokee County public schools. Cherokee High School then became the only secondary school in the county. Pictured here is a pageant at the Ralph Bunche School. (CCHS.)

The Denim Days celebration was held in downtown Canton on August 18, 1958, and crowds turned out to celebrate the product made by Canton Cotton Mills. Booths were set up along Main Street for displays, and vendors served up concessions and souvenirs for the crowds. Mill employees were encouraged to show their pride in their product by wearing clothing made of blue denim. (CCHS.)

Daughters of Canton Cotton Mills employees competed in the Denim Dolls Contest at the company picnic in the 1960s. Pictured in the younger division are, from left to right, (front row) ? Pendley, Emily Smith, Rhonda Morris, Phillis Smith, Joan Bishop, Anne Cash, Brenda Edmondson, Debbie Bagwell, Debra Cornelison, Nancy Page, Bonnie Woodall, Martha Ray, Martha Richards, Jenny Holbrook, Fran Rolan, and Joan Ray. Those competing in the teen division in the contest include (back row) Laurann Lummus (left), Betty Jean Blalock (sixth from left), and Sue Weaver (ninth from left). (CCHS.)

First Baptist Church of Canton, on Elizabeth Street across from Brown Park, had a strong congregation and was influential in the community, with many strong youth programs in the 1950s and 1960s. The church, which was redone in 1925 to its last facade, was later sold to the City of Canton and now serves as Canton City Hall. (CCHS.)

Halloween carnivals were held each year in the old Canton High School gymnasium, which was used in the late 1950s and 1960s by Canton Elementary School for students. The gym was behind the school building on Academy Street and was later torn down. Here, elementary students, parents, and teachers enjoy the festivities of a carnival held in the mid-1960s. (CCHS.)

Jones Mercantile Company continued to dominate downtown as the place to shop when it celebrated 75 years in business in 1954. The business, started in 1879, had evolved to a full department store, with just about anything the shopper could imagine. The door at the far left of this photograph leads to the grocery store. The upstairs featured furniture, and the lower level had hardware. The store had 135 employees at the time. (CCHS.)

Canton in the late 1950s and early 1960s was a festive sight at Christmastime. Main Street would draw holiday shoppers to a variety of stores, including Worley Shoes, Kessler's, and Rosenblum's, as well as Jones Mercantile. Main Street was still a two-way street at the time. The Canton movie theater was a mainstay of the downtown area, and the lower drugstore owned by Henry Daniel is visible on the corner. (CCHS.)

Dr. Grady Coker N. Coker delivered hundreds, if not thousands, of babies at Coker Hospital up until 1962. Pictured here is Dr. Coker (left) with Norman Sosebee, who was the coroner at the time and drove the ambulance that took mothers home with their babies. A nurse holds a baby in preparation for the journey with the waiting mother, while the proud father (holding the suitcase) looks on. The man at right is unidentified. (CCHS.)

Local Dodge dealer John T. Holbrook Sr. presents keys to a new patrol car for the city police department to, from left to right, Chief Roscoe Spears, and officers Sam Hathcock, Ebb Orr, and Charlie Payne, along with police commission chairman Paul Boring and Canton mayor Billy Beard. The event took place in front of Worley's Shoes in downtown Canton. (CCHS.)

Marion Pope speaks at a political rally in downtown Canton supporting the reelection of Pres. Lyndon Johnson and his running mate, Vice Pres. Hubert Humphrey, in 1968. Cherokee County remained a solid Democrat stronghold from the days of Reconstruction until 1990, when it turned almost as solidly Republican in just one election. By the next election, in 1992, every official in the county was an elected Republican. (CCHS.)

Radio station WCHK-AM was licensed to Canton in 1957, and it became a new way for residents to stay in tune with what was happening in the community. Here, Byron Dobbs, on-air talent and later the general manager, is with the news car in the 1960s. Dobbs and the "K-car," as it was fondly called, were familiar sights on the roads of Canton in times of weather crises, news events, and sports games. It was also used for remote broadcasts. (Author's collection.)

Cherokee High School opened its doors in the 1956–1957 school year. The school was built on Highway 5 across the river from downtown Canton on the property that had once been Crescent Farms. That year, the Georgia General Assembly merged the Canton Independent School System with the Cherokee County School System, consolidating Canton High and Reinhardt Institute in Waleska. The first principal was Hal W. Clements. (CCHS.)

Cherokee High School immediately began a legacy of tradition for students, as evidenced by this homecoming parade in downtown Canton in 1961. Members of the homecoming court ride down Main Street to the delight of the crowds. The tradition continues to this day. In this photograph, one of the lovely couples rides in a 1958 Chevrolet convertible. (CCHS.)

The Cherokee Band of Warriors and the Warrior mascot ride through downtown Canton during a homecoming parade in the early 1960s. School spirit ran high at the new county school that graduated its first class in 1957. The Crisler-Green home at the corner of Main Street is visible in the left of the photograph. The house was later torn down. (CCHS.)

In the 1960s, the Bank of Canton continued to be a leader in the community. In 1968, it introduced the first credit card available at a local bank, in partnership with Citizens and Southern Bank. While the significant growth the community would soon experience was just on the horizon, the city's oldest bank was working to make sure it would be ready to meet whatever came its way. The city was also preparing, and in the early 1970s Main Street through downtown was turned into a one-way street. (CCHS.)

The new Georgia State Patrol headquarters in Canton was completed in the early 1960s. The headquarters was built on Marietta Highway near the river and would serve for the next 40 years. In this photograph, taken from the grounds of the Georgia National Guard Armory across the street, downtown Canton is visible in the distance. (CCHS.)

Celebrating the plan for the new R.T. Jones Memorial Hospital in 1962 are community and medical community leaders. They are, from left to right, Ed McFather, N.A. Thomason, Dr. Bill Nichols, Dr. Jack Jones, Dr. Grady Coker, Bob Carmichael, Dr. Jack Cauble, Hamrick Smith, Max Stancil, Dr. Carl Edge Jr., and Carl Barrett. The hospital was the first public hospital in Cherokee County. It opened in 1962 with a capacity of 66 beds. (CCHS.)

Bibliography

Cherokee County Voices From the Civil War. Canton, GA: Cherokee County Sesquicentennial Committee, 2014.
Heritage of Cherokee County, Georgia 1831–1998, The. Cherokee County, GA: Cherokee County Heritage Book Committee, 1998.
Johnston, Rebecca. *Cherokee County, Georgia: A History.* Canton, GA: Yawn's Publishing, 2011.
Marlin, Lloyd G. *The History of Cherokee County.* Fernandina, FL: Wolfe Publishing Company, 1997.
Wagner, Michael. *Canton Cotton Mills.* Waynesville, NC: County Heritage, 2008.

DISCOVER THOUSANDS OF LOCAL HISTORY BOOKS
FEATURING MILLIONS OF VINTAGE IMAGES

Arcadia Publishing, the leading local history publisher in the United States, is committed to making history accessible and meaningful through publishing books that celebrate and preserve the heritage of America's people and places.

Find more books like this at
www.arcadiapublishing.com

Search for your hometown history, your old stomping grounds, and even your favorite sports team.

Consistent with our mission to preserve history on a local level, this book was printed in South Carolina on American-made paper and manufactured entirely in the United States. Products carrying the accredited Forest Stewardship Council (FSC) label are printed on 100 percent FSC-certified paper.

MADE IN THE USA